GREAT TORRINGTON & DISTRICT

THROUGH TIME

Julia & Anthony Barnes,
Susan Scrutton &
Torrington Museum

AMBERLEY PUBLISHING

First published 2014

Amberley Publishing
The Hill, Stroud, Gloucestershire, GL5 4EP
www.amberley-books.com

Copyright © Julia Barnes, Anthony Barnes & Susan
Scrutton, 2014

The right of Julia Barnes, Anthony Barnes & Susan
Scrutton, name to be identified as the Author of
this work has been asserted in accordance with the
Copyrights, Designs and Patents Act 1988.

ISBN 978 1 4456 3417 3 (print)
ISBN 978 1 44563424 10 (ebook)

British Library Cataloguing in Publication Data.
A catalogue record for this book is available from the
British Library.

Typesetting by Amberley Publishing.
Printed in Great Britain.

Introduction

Cheping Torrington as it was once known (Chipping the old name for market) was an important area even in prehistory. Remains of five tumuli, or ancient burial mounds, lie between Great Torrington and the nearby village of Huntshaw. These tumuli have been investigated by archaeologists, and a bronze dagger (9 inches long) found, which is now in Exeter Museum. Berry Castle is an early British camp, which has always aroused much interest from historians.

By the time the Domesday Book was being compiled, Britric held Toritone before 1066. It had land for forty ploughs. In lordship, four ploughs; seven slaves; three virgates; forty-five villagers; and ten smallholders with twenty-six ploughs and two hides; a twenty-acre meadow; 300 acres of woodland; pasture two leagues long and one league wide; twelve cattle; ten pigs; 146 sheep; twenty-five pigmen who pay 110 pigs.

A considerable town, even in medieval times, it grew steadily from its agricultural roots, and its important woollen industry through an industrial phase, at the centre of roads canal and railways. In Victorian times, it had its own, for cornmills, sawmills, grist mills and tucking mills, lime kilns and glove making factory which employed hundreds. In the twentieth century, a giant milk processing plant, abattoir and glass works were added.

Further back in history, the town was the scene of a bloody battle during the Civil War, which lead to the decisive defeat of the Royalist cause. The church was accidentally blown up with gunpowder and over 200 prisoners and townsfolk killed. Many artefacts from its colourful past can still be found here, in the traces of castle walls, built first in the thirteenth century then demolished for lack of planning permission, and rebuilt as a crenelated house in the fourteenth century, and remains of the canal, built in 1823 by John Rolle without act of Parliament. The towpath has been preserved by the Torrington Commoners Conservators and makes an attractive walk alongside the River Torridge.

One of Devon's largest landowners, the philanthropic Rolles, made their home here in the grandest house in North Devon, Stevenstone, and still live in the area at Heanton Satchville. They built bridges, a canal and provided lime kilns and water powered mills as well as rebuilding castle walls on the escarpment above the river.

An early narrow gauge railway was built to bring china clay from the pits at Peters Marland to be distributed to the china companies in the Midlands.

The town has benefitted from its wealthy past in that it is rich in its endowments and has always looked after its townfolk. Chief among these are the Town and Alms Land charity and the Commons Land charity which have for centuries provided help to the needy.

At Taddiport, an isolation leper hospital was established in the thirteenth century, and the strip fields which they worked can still be seen from Castle Hill.

The town's location on a cliff above the River Torridge is beautiful, and its attractiveness is enhanced by the Commons, land around the town that was given in perpetuity to the town in the twelfth century. Although owned by the Lord of the manor, they had no rights of enclosure. It is now cared for by the Torrington Commons Conservators and is one of the most attractive features of the town. It has been protected by an Act of Parliament since 1889.

Nowadays, Torrington has managed to avoid the excessive development that has blighted so many local towns, and as a result much of the original layout and features can still be found. However, fierce fires have destroyed many of the thatched buildings and town records and several large houses have disappeared completely.

When writing this book, it was a pleasure to talk to the townspeople. Was there ever another town so full of people who know so much about their local history? This has manifested itself in the nature and quality of the local museum, which has at last been given a new home in the centre of the town, and whose photographic collection is the book's basis. This book is dedicated to the people of Torrington.

Acknowledgements

Grateful thanks to the many people who welcomed the use of their old pictures and memories and gave freely of their time: Great Torrington Museum; Val and Peter Morris; Tillie and John Kimber; Ann White; Judith Domleo; Hugh Reed; Barry Hughes; PGL Adventure School; Michael Loud; Knight Frank and Rutley (estate agents); Adrian and Hilary Wills; RHS Rosemoor Sally Charleton; Sheila Dearing; Lady Anne Palmer; Buckingham Arms; Rowena Cotton; Landmark Trust; Globe Hotel; David Haywood; Castle House; Peter Turton; Sarah Chappell; Compass; Sandfords the bakers; Martin Pow; and the many other people whom we spoke to but never learned their names.

Around Torrington: Houses

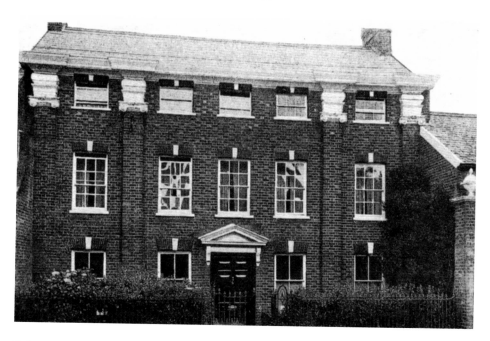

Palmer House, New Street

This most imposing house in New Street was built in 1752 by John Palmer, mayor and attorney and brother-in-law to Sir Joshua Reynolds, who often visited this house to see his sister. Built of red brick with giant Ionic pilasters and a grand pedimented doorway, the house is unusual for New Street in that it actually has a front garden with piers and vases. Inside there is a particularly beautiful plaster ceiling in a ground-floor room depicting the Palmer arms. The gardens and grounds were once extensive, and the back portion of the house was added later. The dining room was designed to resemble the cabinet room at No. 10 Downing Street. The stables and outhouses of Palmer House were converted into Nos 6 and 8 New Street.

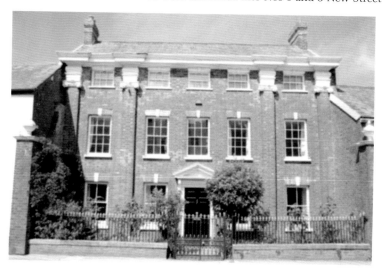

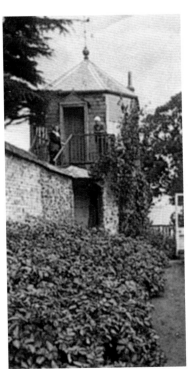

Old Gazebo, Palmer House

In 1897, the Palmers sold Palmer House. The estate was divided up and the beautiful gazebo in the grounds ended up marooned between several boundary walls. Although Grade II listed, the house was allowed to deteriorate with nobody to maintain it, and somebody even kept their horse in it at one time. By the 1990s, it was on an English Heritage list of buildings at risk. The Devon Historic Buildings Trust decided to act and to save it, and the decision was taken to remove it to RHS Rosemoor Gardens. By this time, the gazebo was so trapped between different garden walls and so inaccessible that it had to be moved manually by wheelbarrow after it was carefully dismantled and the pieces marked. The ground floor storey was built as before of cob and natural stone, and then the gazebo was rebuilt as the first storey on top of this. The whole process took five months and it was opened in September 1999. Inside, there is a slate hearth and fireplace with china cupboards on either side. RHS Rosemoor provides a beautiful setting to this historic building. The gazebo was designed to benefit from the light from a north window. Sir Joshua Reynolds is reputed to have used it as his studio when staying with his sister, Mary.

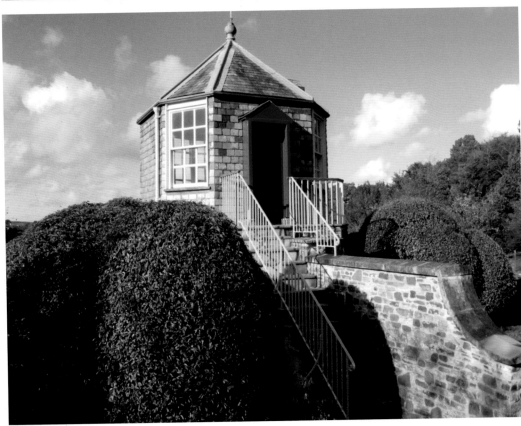

Cawsey House, No. 28 South Street
This beautiful and elegant house was
built in 1701 as a merchant's house,
but for a very wealthy merchant. This
is a wide, generous plot, not a narrow
burgage one like the small houses
further down the street. By this time, it
was the fashion to have two reception
rooms at the front, so the drawing
room no longer needed to be on the
first floor. The owner was well-to-do, so
the ground floor rooms were planned
as private family rooms and not used
for trade. The beautiful plasterwork
ceiling in what was then the parlour
featured musical instruments. The
acanthus leaves in the other rooms and
the door shell hood on the street façade
are all thought to be by the Abbot
family of plasterers of Frithelstock.
The owner of the house at the time it
was built was Giles Cawsey, the town
clerk of Torrington from 1698 and a
merchant in the town. A rainwater
head on the façade, dated 1701, has his
initials and those of his wife Margaret.
The house bears a close resemblance
to the beautiful merchants' houses in
Bridgeland Street in Bideford and to
Palmer House in New Street.

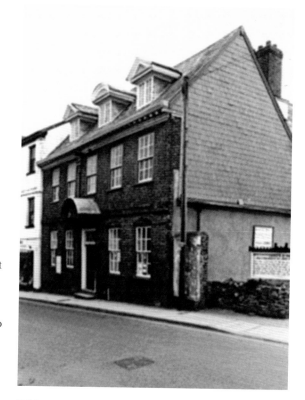

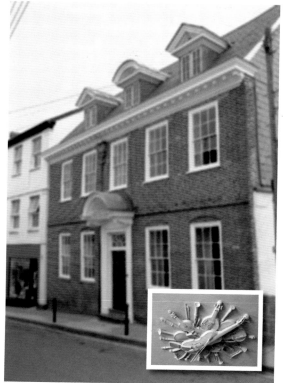

Cawsey House

The Cawseys' descendants lived in the house into the nineteenth century, when it became the Liberal Club. The house deteriorated in the nineteenth and twentieth centuries, when it was relegated to being used as offices and a clubroom. In the 1920s, the house was divided up, and by the 1980s it held a Masonic lodge, the Girl Guides, the Red Cross and the Town Lands' Charity, which still owned the lease. Its fortunes finally changed in 1996 when it was rescued and restored to its former glory as a holiday home by the Landmark Trust, together with the Stevenstone Orangery and Library; this institution has been a good friend to Torrington. They had just finished restoring the shell porch when it was hit by a lorry, and further work was needed once again. During the First World War, the Ministry of Fisheries and Food used rooms here. You could collect orange juice, cod liver oil and rose hip syrup for children, get your ration books, or to buy chicken meal for the hens people kept in their gardens to supplement the meagre wartime rations (though your ration of one egg a week had to be sacrificed if you wanted to buy chicken pellets instead). The inset shows Cawsey House in its club days.

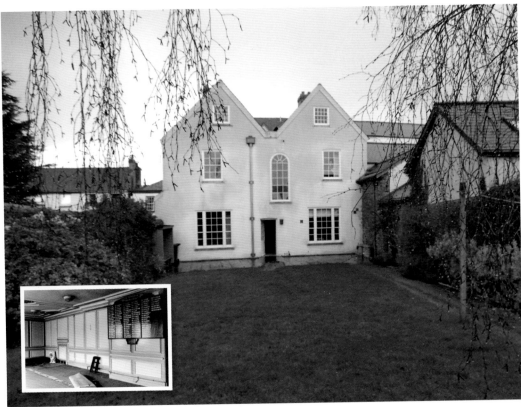

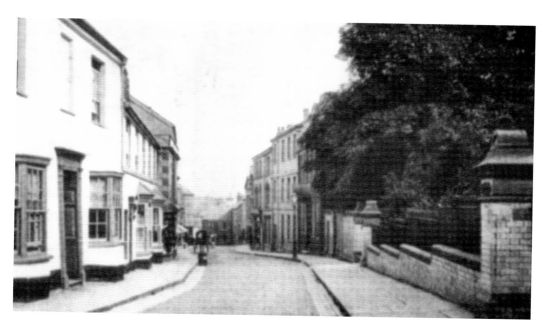

Site of Old Rolle Arms (South Street)

The pillars on the right of the old picture, formerly the entrance to Sydney House, are now the entrance to South Street car park. Before this, it was the site, leased from the Rolles, of a very large, old inn, first called The Rose and Crown. In 1710, Peter Sweete, a serge weaver, left to his daughter Elizabeth in his will, 'my right in the Rose and Crown'. It later became The George, then the Ship and, by 1851, the Rolle Arms. It had a parlour, two kitchens, sitting rooms, bar and spirit rooms, seven bedrooms, a dining room, a brew house, extensive cellars, a dairy, a malthouse, two gardens and a meadow. It had stabling for 100 horses, which was well used by farmers visiting the town on market days. Coaches left from here to Exeter and Plymouth and the inn rooms were used for auction sales and inquests. A savage fire broke out in the brew house in 1886 and raged all night. The firemen were summoned by the market house bell and by bugle calls, but the inn was gutted by the fire and that was the end of the Rolle Arms.

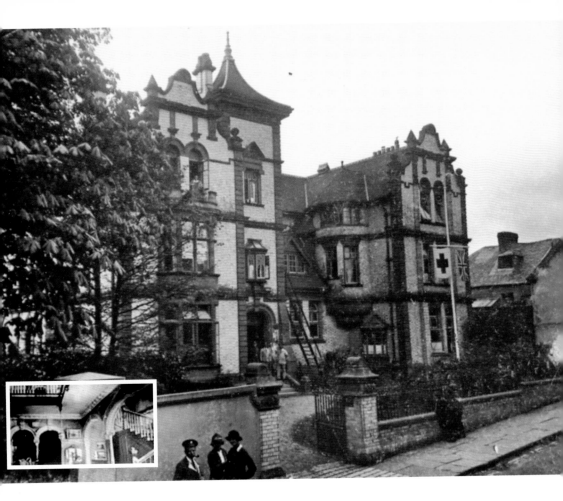

Enderley, South Street

Having built the large and successful new glove factory in White's Lane, William Vaughan turned his attention to an equally imposing mansion for himself and his large family. He leased the site of the burned-out Rolle Arms, as well as the house next door, for ninety-nine years, and built the biggest house in Torrington by far. It was an enormous mansion with turrets and pinnacles, two enormous drawing rooms, a hall the size of a ballroom, a billiard room, music room, smoking room, dining room and spacious servants' quarters. There were eight large bedrooms on the first floor and four on the second. Outside were a gardener's cottage, stables, a coach house, harness room, cow stalls and pigsties, two large conservatories and a gazebo. There were two sets of double gates for carriages. Here, they lived in great style until William's death in 1903, when this magnificent way of life came to an abrupt end. In 1914, the mansion was offered for sale but a buyer could not be. A country mansion in the middle of a town was an unattractive proposition. A month later, England was at war and Enderley made an ideal hospital with fifty beds for the many wounded soldiers. Under the auspices of the Red Cross, it was known as Enderley VAD Hospital.

Enderley Becomes Sydney House

After the First World War, Enderley became an open-air school for delicate children and was renamed Sydney House. The photograph below shows the view from the back. The windows were kept open at all times, the children were lightly dressed, private possessions were discouraged, visitors were restricted to two hours a month and all letters were censored. Life there must have been bleak, and the children remembered it as a sad place with poor food where many of them were unhappy. During the Second World War, ailing evacuees boarded there as well. They remember lumpy porridge with salt, as sugar was rationed, followed by cleaning chores and long walks, and a scanty education. The night of 19 February 1942 was bitterly cold. At 7.30 p.m., all the children were in bed and an icy wind was sweeping across Castle Hill when a fire broke out in the linen room, which spread rapidly. The staff were horrified to find that five boys were tragically missing. The firemen fought all night to extinguish the fire, but the night was so cold that water from the hoses froze underfoot and the men kept slipping over. Three boys were found but they couldn't be revived, and the other two were discovered next morning in the rubble. Eventually, the whole site was cleared to become South Street car park, and a peaceful memorial garden was created in memory of the children.

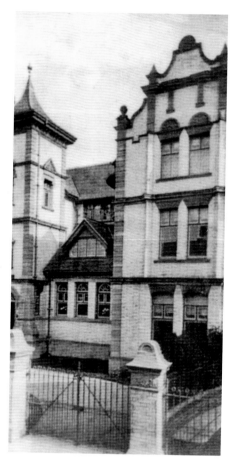

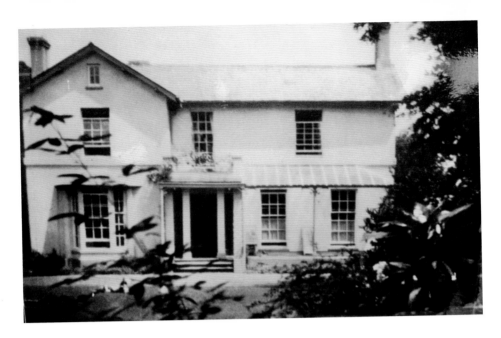

Torrington Vicarage and Manor House

The vicarage (1841) is on the site of the manor house of Lady Margaret, who was Countess of Richmond and Derby (1442 to 1509). The mother of Henry VII, she lived here for a time and owned the barony of Torrington. She gave the church a magnificent library filled with a collection of books. The poor rector at that time was living out at Priestacott and had to travel a long distance to take services in all weathers. Generously, Lady Margaret allowed her 'manor house with lands thereunto belonging' to be his rectory. The manor house grounds, which included a farm, were extensive and surrounded by a moat. They were rapidly disappearing by 1875. The grounds would have extended right across to the church, before the road was built that divided rectory from church. Even in Victorian times, the grounds included the present-day plant nursery, the children's playground, the southern end of the football pitch, the swimming pool site and its car park. Lady Margaret's inheritance passed to her grandson, Henry VIII, when she died.

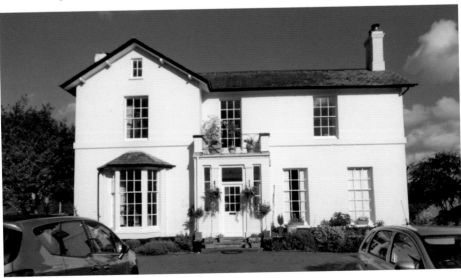

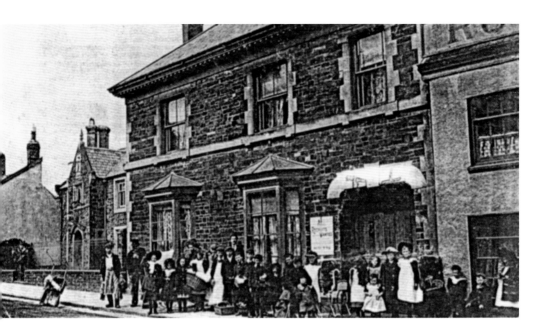

No. 88 New Street

This old house was built around 1860, possibly by John Long, a glove manufacturer, and it has been known as The Hermitage and The Retreat. The side doors to the right of the building open onto a side passageway where a horse could go through to a cobbled stable yard and stable. There is a long back garden, outhouses and even a small piece of woodland. The house itself extends backwards a long way too, and there is a very large room at the back that was used as a glove factory at one time, with workers accessing it via the side passage. The old photograph was taken when it was still a glove factory. The noticeboard says 'Recruits Wanted', though this was for Army recruits. Later, this room was used by the Roman Catholics of the town as their church and Sunday school before their new church was built in Gas Lane in 1964. A bell hung in the yard outside to summon the congregation to morning service. As with so many other houses, this big house was requisitioned in the Second World War. US soldiers were also billeted here.

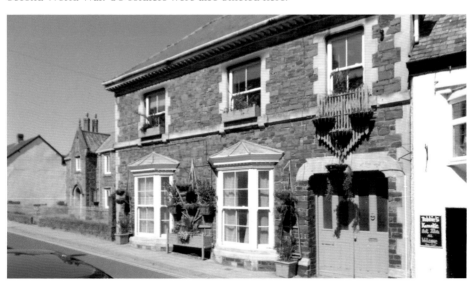

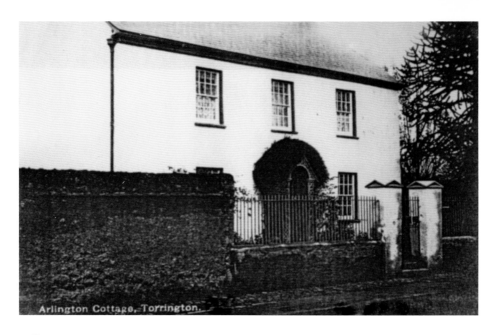

Arlington Cottage, Torrington.

Arlington Cottage New Street, *c.* 1930

This was one of the most attractive Georgian family houses in Torrington, set back from the road with extensive gardens, which included a tennis court. However, by the 1890s, Elizabeth Martin was letting out apartments and rooms here. With the increase in vehicle ownership, many of the old cottages in New Street had nowhere to park their vehicles and parking became more and more of a problem. The council first considered demolishing some houses opposite the Royal Exchange pub, but finally settled on this beautiful house on the other side of the road. For Arlington Cottage, this was the end, and New Street lost an elegant villa. This all became the public car park and, later, the site of a large supermarket.

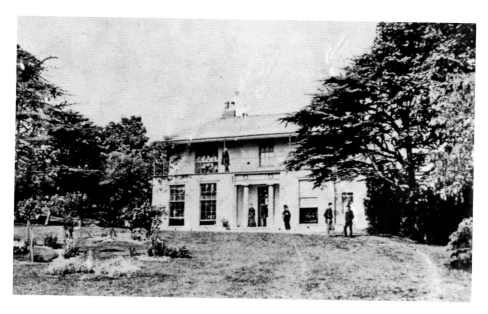

Castle House, Castle Street

This fine Georgian house was built on the castle curtilage and became part of the Rolle Estate. In 1793, it was rented by the Glubb family while they waited for Corner House in Potacre Street to be built for them. A document at that time described it as 'bounded on the North by a lane leading to the Common Castle Garden'. By 1820, Elizabeth (Betsey) Deane, a niece of Joshua Reynolds, was using it as her townhouse. Her main house at Webbery was too remote for much of a social life. Sadly, nothing remains of the observatory that was built in the garden (no light pollution in those days). In 1825, she sold the lease of the house to her nephews for them to take possession of the 'furniture, prints and plate and the tenement called Castle House ... together with lawns, gardens, stables, coach house', yet she continued to live there. In 1833, only eight years later, her son, Anthony, was in Fleet Prison for debt. Was she, perhaps, protecting the family assets from sequestration by his debtors? At that time, the gardens were much larger and the lawns extended to the south. The house is now a nursing home.

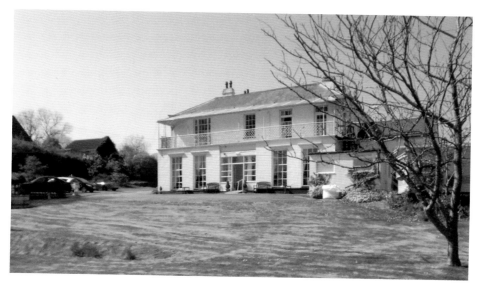

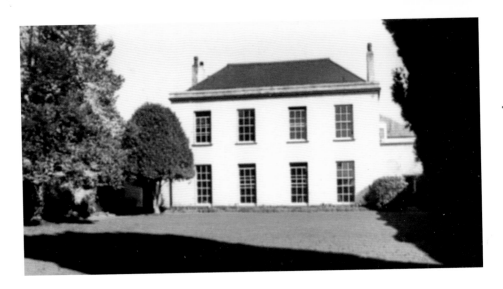

Castle Hill House

The house, built around 1820 as a grand private house, has a most beautiful curved cantilevered staircase lit from the roof lantern. The views over the river valley are magnificent, and the garden has battlemented walls with an interesting, old stone staircase leading through a tunnel to the walkway below. A senior member of the Home Guard was billeted here during the First World War and was in charge of the armoury. Being such a large town house, it later became an hotel and then fell into disuse. It was bought by the Landmark Trust, partly to save No. 28, and leased for 999 years to the Community Development Trust. It now houses the library, council offices, Torrington Information Centre and Torrington 1646 (an imaginative themed museum based on the Civil War). The tragic death of the five children in next-door Sydney House is remembered in the Secret Memorial Garden in the side garden of Castle Hill House.

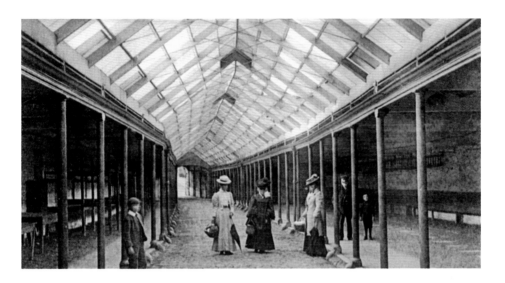

The Market House, Site of White Swan Inn

This site was originally the White Swan Inn, which was in existence by 1634 when it was sold to a new landlord. It was on a big site even then and described as having several dwellings, tenements, courts, gardens, though the actual rent was 'one peppercorn'. In 1841, the Borough Council met 'to consider the messuage and tenement commonly called the White Swan Public House for purpose of building a Market House thereon'. Originally, the market was just held in the open streets and the butchers sold their meat in the Shambles, the narrow street behind the town hall, which gave some shade to the meat. In 1842, the new market was built with Ionic pilasters between the arched windows and Doric columns inside to divide the market stalls. On the first floor were the galleried Market Hall, which was used for lectures, balls and concerts, and the Assembly Rooms that were here before 1861. This room became the town library and is now part of the town museum. The glass roof was removed in the Second World War in case it attracted enemy bombers, but in 1996 the town was awarded a grant and a new glass roof built.

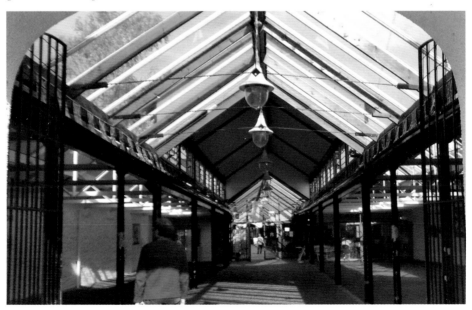

Railways

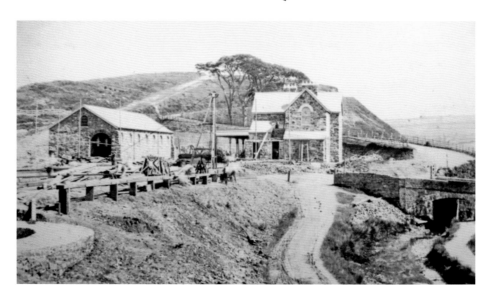

Torrington Station Under Construction, 1871

On the left of the picture is the goods shed on the far side of the station, and behind it the old carriage drive can be clearly seen going up the hill. In the centre of the picture is the stationmaster's house, now the Puffing Billy pub, with the station canopy clearly visible. In the left foreground is a section of the engine turntable in the process of being built. On the right-hand side is a bridge carrying the road that once came up from the old Rothern bridge and passed over the Rolle Canal. The road has been rerouted with a sharp right-hand bend to carry it past the new station. The track coming up from Staple Vale and from Rothern Hotel is in the centre foreground, and on the right are the canal and the towpath, not yet infilled. The new picture is taken from a similar position, and the canal, towpath and bridge carrying the road from Rothern Bridge have been completely buried.

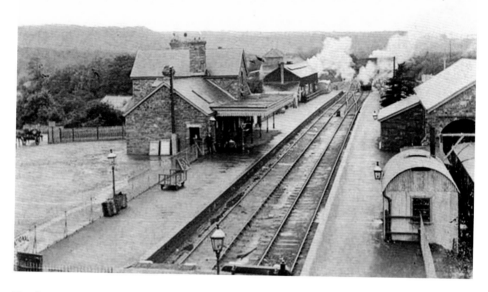

Torrington Station Terminus Opened, 1872

The Torrington Extension Railway finally opened on 18 July 1872 after many years of delay. The old photograph shows the station when it was still the terminus of the line, and this is how it remained for the next fifty-three years, with its station booking office, waiting rooms and the stationmaster's house. On the other side of the line is the small passenger waiting shelter and behind that the large goods shed, with three lines running into it. On the far side of the goods shed, sidings served cattle pens. The station goods yard and engine shed became very busy, as workers operated throughout the night, unloading 20 tons of Welsh coal from the wagons, oiling engines and scraping out clinker. Men slept in a cabin, which was an extension of the engine shed with a hot fire burning continuously for frying food and heating. Extensive yards were built here for the dairy factory, which took milk from 3,000 farms. Much of this was dried to make powdered milk, and in 1957 the trains took 2 million gallons of fresh milk to London. The yard had its own access road to take milk tankers into the goods yard.

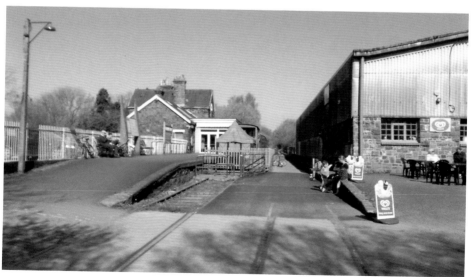

Old Roads and the Commons

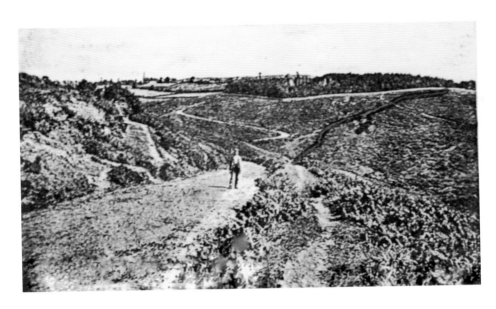

Limers' Road

Limers' Road, which leads down from the old Bowling Green at the top of Station Hill and winds down to Taddiport, is the end of the old packhorse trail carrying goods from Weare Giffard. The old road, which left the Weare Giffard Road near to the present golf club, went down the hill, over Common Lake stream and up the hill on the other side to the Old Bowling Green and on down to Taddiport. The bridge at Taddiport was built around 1260, but before this there was a fording place downstream called Fordham or Stoneyford and Limers' Hill went straight to it. This old route was rendered unnecessary by the building of the Rolle Canal.

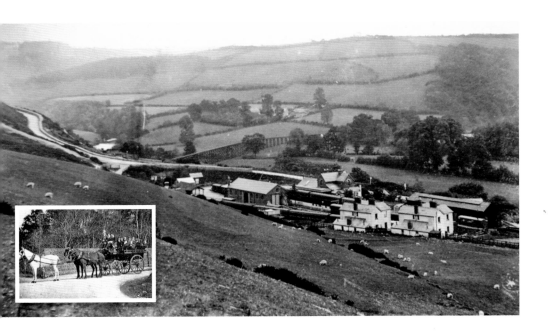

Carriage Drive/Station Hill

The carriage and horses standing by the wall of the cemetery (*inset*), are about to descend the hill on the old carriage drive to Bideford, which ran downhill from the Old Bowling Green parallel with the present Station Road. The new picture shows it today as a track that is still cobbled in places. The way down to the station has had at least three different routes. The building of the station in 1872 altered the course of the Victorian road, and the old sepia print shows the station and the two routes up the hill at that time. The carriage drive is on the left and the Victorian road with its raised footpath is just to its right. In 1928, the new Station Bridge altered the road's course again, providing a new tunnel to take the extended railway to Halwill and incorporating the Petersmarland tunnel, which can be seen in the old print. Finally, in 1967, Station Hill was altered yet again to another new line further away from the edge of the escarpment, which was suffering from subsidence at the edges. This is its position today.

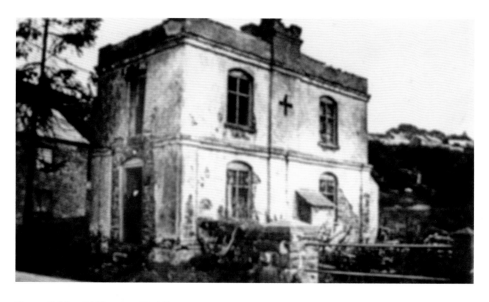

Town Bridge Tollhouse, Taddiport

This old tollhouse was built by the Great Torrington Trust around 1830 to control the road from Hatherleigh and Plymouth, which came in through Taddiport, across the Town Bridge and up Mill Street to the town. It is shown on the 1834 OS map and called 'Bridge Gate', denoting a tollhouse there. The gates of the tollhouse by the bridge were still there in 1879. It was close by the Rolle Canal offices, which would later become the Torridge Vale butter factory. Later, Mark Rolle hoped that it would also serve as a tollhouse for his new Rolle Road along the infilled Rolle Canal bed, but this idea was abandoned. In 1871, the toll collector was thirty-three-year-old Robert Mitchell. The elegant tollhouse is Grade II listed, with ashlar pilasters and a high parapet wall obscuring the roof. The modern picture shows how it has been extended at the rear.

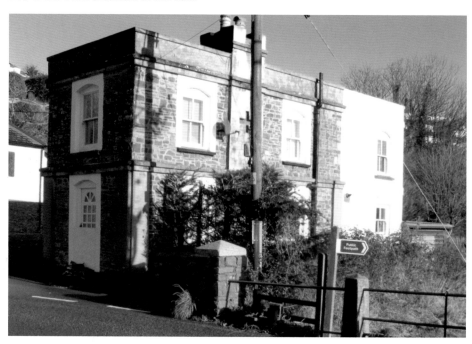

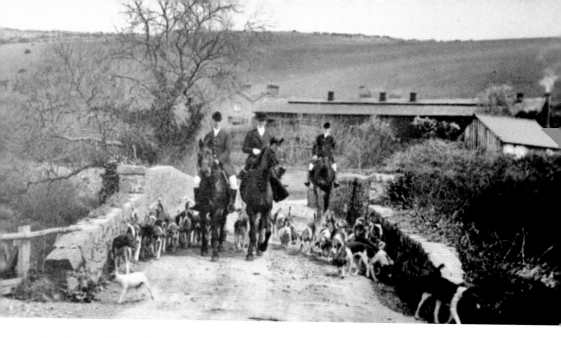

Torrington Tolls and Rothern Bridge

Tolls needed to be collected day and night on the turnpike roads, so small houses were built by the tollgates for the collector. They were usually extremely basic, with only two rooms and a privy, a projecting window to give views up and down the road. The Trust came into operation in 1765. Torrington had seven tollhouses in and around the town, though only two of them are in existence now at Taddiport and Rakeham. Rothern Bridge tollhouse at Rakeham was built where the road from Bideford came down from Monkleigh and went to the old bridge, which survived a proposal to be demolished and is now graceful in listed retirement. When the new bridge was built at New Town Mills in 1843 for the new road to Plymouth, a tollhouse was built just before the bridge, replacing one that had been built near the entrance to Rosemoor House where the old road to Exeter used to pass between the house and the outhouses. Called Rowe's Moor Tollhouse, the remains of its walls can still be seen by the old entrance gates to the house. Other tollhouses were in Calf Street at its junction with East Street and at Castle Garden Lane and School Lane.

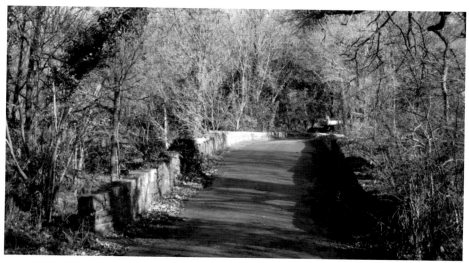

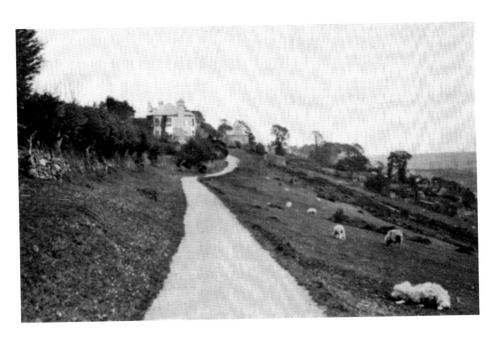

Warren Hill Looking Towards Warren Lane

In 1843, the Mill Street end of Warren Lane was called Rack Park Lane and passed an area where the woollen cloth was put on the racks of tenterhooks to dry. Warren House is very old and probably so called because its owners ran a rabbit warren here and bred rabbits to supply meat to the market. The house had a coach house, stabling and a garden. In the 1860s, when it was part of the Town Lands and was rented out to tenants, the trustees considered whether to allow it to be used as a smallpox hospital because of its more isolated position. In 1923, it was sold by Town Lands. Uplands and Rock Mount are on the left of the old photograph and Torridge House on the right. Torridge House was built around 1870, and its garden stretched down to Mill Street. Hillside next door was built on its old tennis court.

Industries

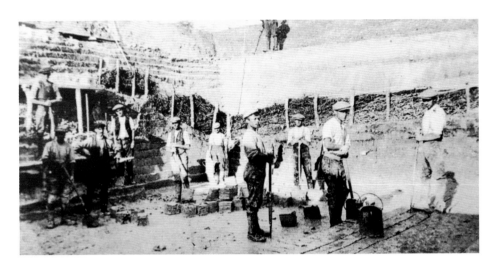

Ball Clay

The ball clay found in Peters Marland, which is used to make the distinctive cream-coloured bricks seen locally, was formed around 30 million years ago. A massive fault line, the Sticklepath fault, ran north-west to south-east from cliffs in the Abbotsham area to Torquay. The climate was very hot and wet, and swampy freshwater lakes formed in the basin of this massive fault line. Sediment from the surrounding granite mountains was washed down into the basin, forming the fine-grained ball clay. Swamps formed in the lakes, with floating vegetation and huge trees like Sequoia, and the landscape resembled the Florida Everglades of today. The foreman stands on the top, keeping an eye on the workers to prevent shirking. Lines of slits have been marked out ready to be cut into 9-inch cubes with 9-inch spades. Many of the men worked underground, supporting their tunnels with pit props. There were kilns with three tall chimneys on site, and thousands of cream coloured Petersmarland bricks were made there every day. At that time, the clay was made into tobacco pipes, and, later, for making electrical insulators and basins.

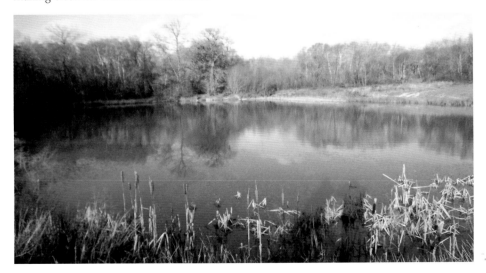

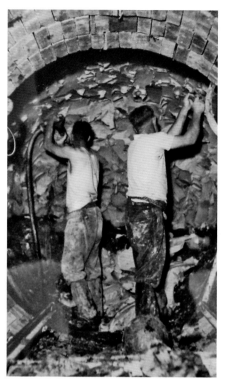

Petersmarland and Meeth Clay and Brickworks

The Petersmarland clayworks have been operational since at least the seventeenth century, though the site was very inaccessible. By the 1700s, clay was being sent to the Staffordshire potteries for heavy duty pottery and basins. At first, the heavy ball clay was loaded onto pack ponies and carts to make the difficult journey to Weare Giffard for its onward transhipments by river, but the opening of the Rolle Canal at Taddiport greatly improved links. The clayworks wasted no time after the railway reached Torrington in building their own rail link to Petersmarland. They had to make a narrow tunnel from the station, under the main road and then build a wooden viaduct on stone piers over the River Torridge. The whole line was built very cheaply on a narrow gauge, with sharp curves, steep gradients, timber trestles and viaducts instead of embankments. Some of the gradients were 1 in 30, and the engines usually carried boxes of sand to improve traction. It opened in 1881. The only passengers carried were clay workmen who left Torrington at 6.30 a.m., although more were picked up at Watergate and Yarde.

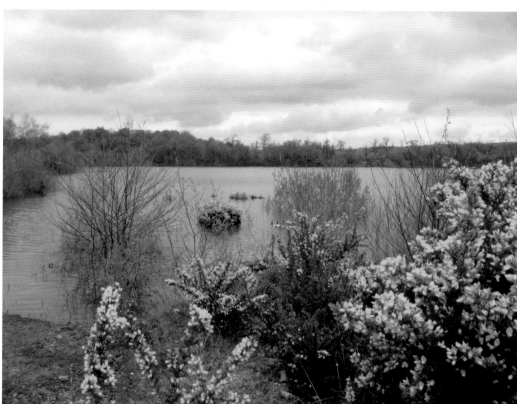

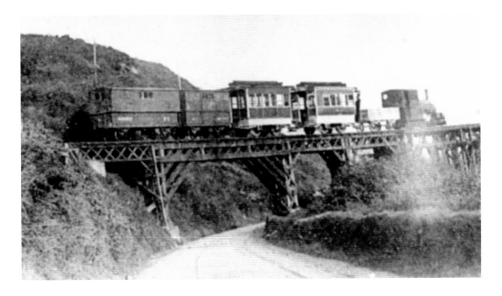

Old Railway Viaduct and Workers' Carriages

This was the first railway viaduct built for the Torrington & Marland Light Railway to transport ball clay 6½ miles from their Marland Clayworks. It was opened in 1880 exclusively for the clay works at Peters Marland. The original viaduct was all timber-built, but when plans were drawn up in 1925 to extend the main line on from Torrington to Halwill Junction as a standard gauge line, a new viaduct was constructed side by side with the old. The new line followed the course of the old one to Dunsbear and then veered away to avoid the clay company site. If these carriages remind you of pictures of old trams, it's because they were. These picturesque carriages were used to transport the clay workers to the Peters Marland Clayworks, but were originally London County Council horse-drawn double-decker trams built in 1882. The enterprising Torrington & Marland Light Railway Co. removed the stairs to the upper deck but left the seats in situ exposed on the roof, and they can be seen here on top of the quaint carriages.

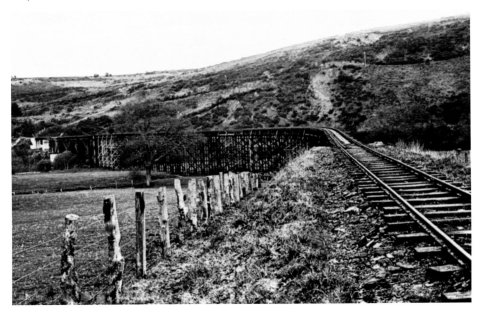

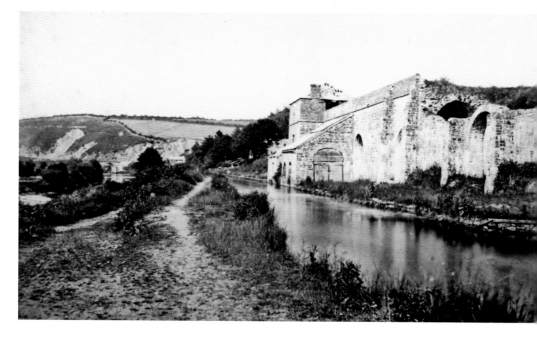

Rosemoor Lime Kilns

Plans for the improvement of Torrington envisaged the construction of the canal, New Town Mills and the five lime kilns at Rosemoor as a single project. A leat already existed from Darkham weir on the Torridge, to feed a tucking mill behind Rowe's Moor, and this was widened so that it would provide water to power the New Mills and feed the canal. It also allowed a wharf to be built alongside the lime kilns to offload the coal and limestone needed to supply them. The empty tub boats could then be towed back to Town Mills to load goods for shipment to Bideford. When the canal was closed in 1871, it signalled the end of operations on the site and the kilns fell into disrepair. The old photograph shows a strange construction on top, which appears to be an office with a chimney and fireplace.

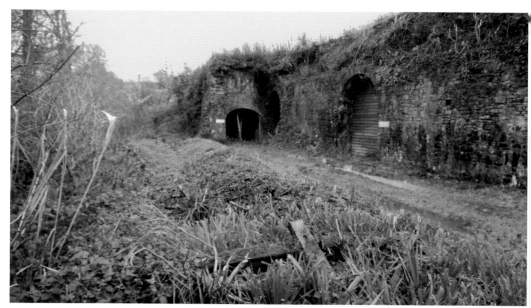

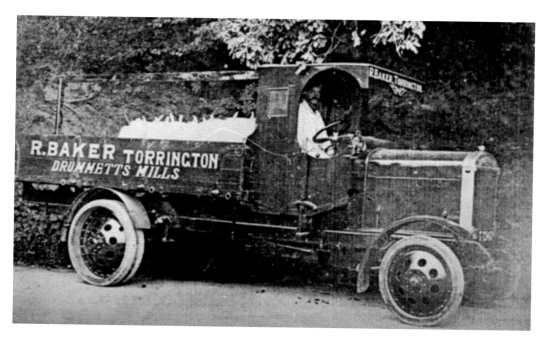

Drummett's Mill

Drummett's Mill is a very ancient grist mill. It ground grain for commercial use, buying in the corn, but also milled corn for individual customers who brought along their sacks of grain for grinding. In the latter case, the miller would take a proportion of the output as 'grist' or payment for his services. In 1885, Thomas Ford was the farmer and miller here at the mill and he employed six men on his 100-acre farm and as workers in the mill itself. It was an overshot waterwheel and the leat ran from a tributary stream, which runs down past Watergate and back into the River Torridge. The leat also powered the tucking mill just up the valley here and then ran on to Drummett's. The old lorry delivering sacks of flour has solid rear tyres.

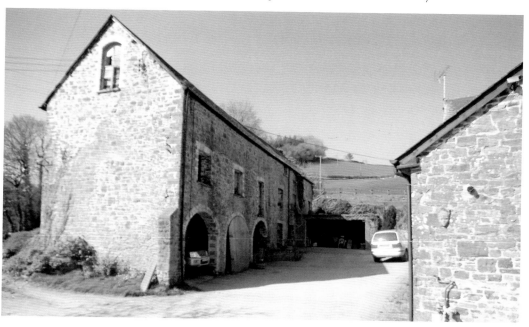

Vaughan Tapscott Glove Factory in White's Lane

Glove making in Torrington has a very long history, as the Subsidy Rolls of 1543 record 'John Williams, Glovyer of Newstrete'. The industry was subsidiary to woollen manufacturing for hundreds of years, but, by the late eighteenth century, the wool industry had fallen into decline and gloving was thriving. By 1861, 60 per cent of the female labour force of the town was employed in glove making at twelve manufacturers. The Vaughan factory was originally in Mill Street, until it outgrew its premises. William Vaughan was a staunch Bible Christian and built his new factory to resemble a chapel-like building in Marland brick. Cheap imports and changing fashions led to the gradual decline of English gloving. White's Lane was originally in two halves, with the south end wider and forming a continuous lane with Church Lane.

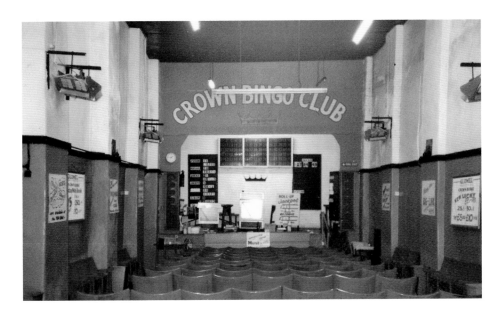

Tanneries in Torrington

There were tanneries for the leather industry in Torrington right up to 1925. The Bullring Tannery was in Church Lane, behind a house belonging to it in High Street, where Ferry's hardware shop now is. The site in Church Lane was once the area where bulls were baited in the belief that it made the meat more tender. Later, when it was a tannery, there was a huge shed there for storing the bark, later converted to a cinema, then a Bingo Hall and finally Tannery Row. The house in the High Street became a dwelling and gas company offices. Chapple's Tannery was at the top of what is now New Road. Other tanneries were on the east side of Stoneman's Lane, No. 4 Castle Street, Caddywell, Mill Street and South Street. In those days, woods of coppiced oaks were all around the town. Tanneries employed a lot of people: coppice workers to cut the wood and strip off the bark, as well as many in the tanneries themselves. Cordwainers or shoemakers used the leather as did all the harness makers and the glovers.

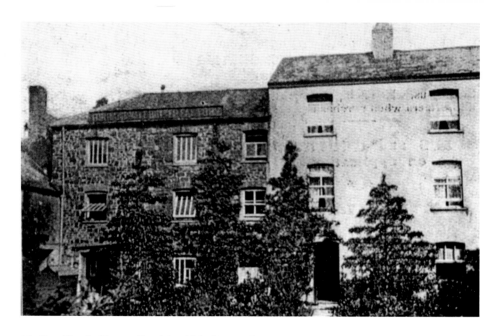

Mr Sandford's House, Torridge Vale Butter Factory

These buildings were originally canal warehouses, stores and offices for the canal company, and were situated on the busy canal complex site at Taddiport. When the canal closed, the council considered turning these buildings into an isolation hospital for smallpox patients, but the idea was abandoned and Mr Sandford leased them from the Rolle Estate as a dairy and market garden. He converted the canal offices into a house by raising the roof and, ever the keen gardener, grew espaliered trees up the house wall. His house was not demolished until 1982. The house on the left is the old malt-drying building and associated chimney. For some time he had been running a market garden further up Mill Street, where it is still called Sandford's Gardens. He had three acres of orchards and market gardens on the dairy site, with further orchards on the other side of the river. He employed fifty people and grew vegetables, fruit and flowers for the local shops and markets as well as producing milk and butter. The enterprise grew over the years until it was Torrington's largest employer in the 1990s.

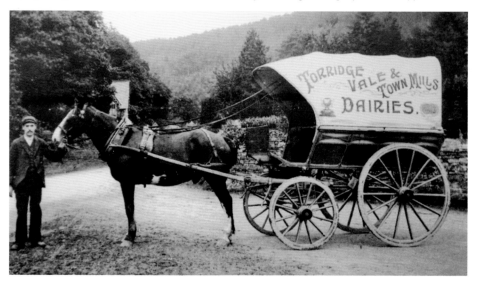

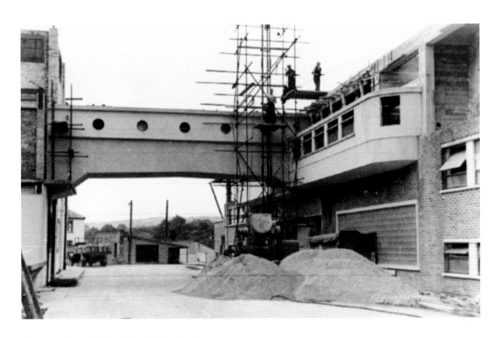

The Demise of Torridge Vale Dairy

What errors of judgement could have caused one of the largest milk-drying and processing factories in the whole world to collapse completely? It was hugely profitable and, at its height, employed 330 people in Torrington, took in 60,000 gallons of milk a day from 2,600 farms and was just receiving a £19-million upgrade.

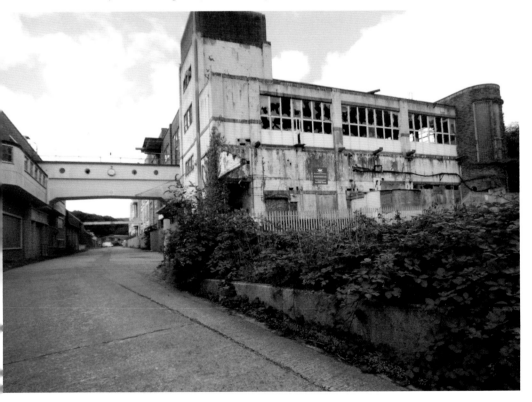

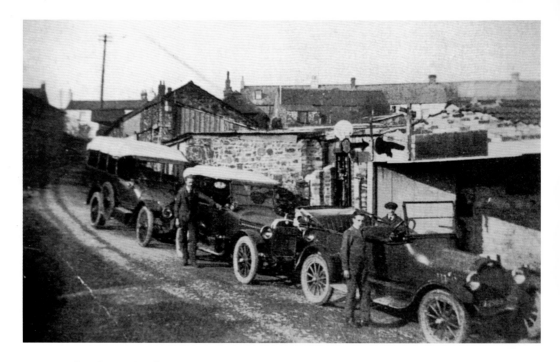

New Road and Mr Friend's Garage, 1927

This was never a very 'new' road, as it was well used even in 1830 as an access track down to the new Town Mills at the bottom of the hill. For many years, though, New Road only went up as far as Well Street where it ended in a T-junction. There was then only a very narrow alleyway further east along Well Street called Rosemary Lane, which went through to Calf Street. Later, houses on both sides of Well Street were demolished, both to dramatically widen the top of the already existing section of New Road and to drive the road straight on through to Calf Street. Little Rosemary Lane disappeared. In 1927, Mr Friend described himself as 'a motor car proprietor' cars and charabancs for hire, motor car repairer, Telephone Torrington 35', and gave his address as No. 55 Well Street. The old photograph has a variety of cars outside his garage, a charabanc, a petrol pump, a smart chauffeur in a cap and several large garage sheds. The location was not easy to place as the garage has gone, the road much widened, but the skyline roofline of Well Street has remained remarkably the same.

Old Town Mills

The original mills for Torrington were at the bottom of Mill Street, downstream from the bridge. They provided a grist mill, a tucking mill and a corn mill, and derived their power from three waterwheels fed from a leat upstream on the Torridge. No trace of this leat can be found, and it is possible that it was subsumed into the canal when it was constructed. It is known that James Green, the canal designer, was paid for the installation of machinery at New Town Mills, and much of this is likely to have been saved from the demolition of the old mills. In the old oil painting of the Taddiport bridge area, the three wheels can just be discerned on the left of the picture. The date is around 1821. This site became Sandford's dairy and market garden, which then grew to become the huge milk processing plant.

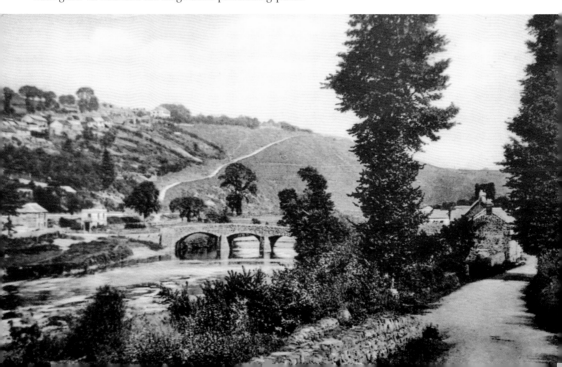

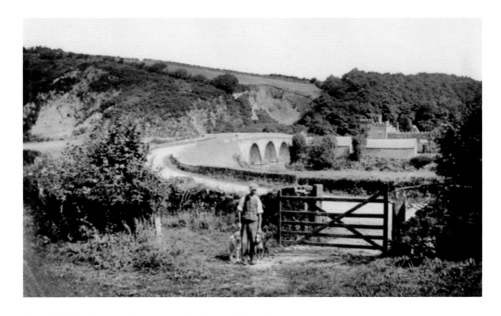

The Rolle Bridge at New Town Mills, Looking East, *c.* 1900

We are looking back at the Rolle Bridge from the Plymouth road. This tranquil scene serves as a panorama of building works that the philanthropist John Rolle provided for Torrington to improve transport and industrial facilities. He built the new bridge here on the Plymouth road in 1843 to replace the steep hill up from Taddiport. On the far bank of the Torridge, the New Town Mills complex can be seen. The mills were powered by two waterwheels, which can still be seen there today, fed by a stream coming down from the lakes at Stevenstone and from a leat dug from Healand (or Darkham) weir a mile further on upstream on the River Torridge. The leat also powered the tucking mill, the remains of which can still be seen below Rosemoor Gardens close to the ruined lime kilns. There was an old tollhouse here called Row's Moor Toll Gate, and in 1871 the toll keeper was seventy-one-year-old Joseph Hammon.

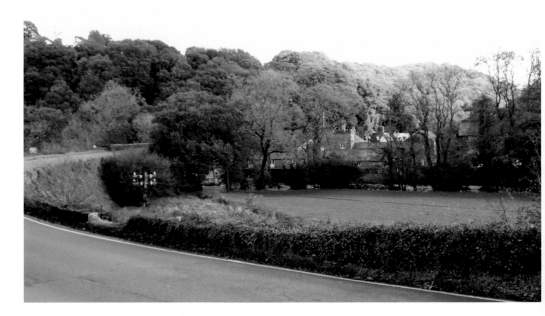

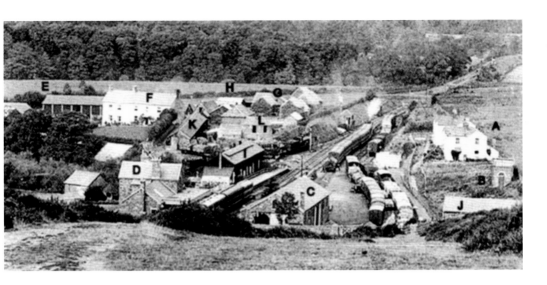

Staple Vale in the 1920s

Above: (A) Railway workers' cottages; (B) Water tanks; (C) Goods shed; (D) Stationmaster's house; (E) Wool-drying shed; (F) Staple Vale manager's house; (G) Hay rick (for farm); (H) Hedgerow marks the line of the Rolle Canal; (I) Engine shed; (J) Pump house for the water tower. Staple Vale was a forerunner of a modern industrial estate. Torrington was suffering from a shortage of jobs in 1777, when 50 acres of Torrington common were enclosed to create grazing and a woollen manufacturing facility for the provision of employment in the area. Wool was washed in a shed perched over the Common Lake stream and then dried before being spun and woven. A manager's house was built in 1815, but the manufactory was never very successful and gradually faded. The company began other activities, started a farm and supplied coal and meat, and all this was supported by the arrival of the railway in 1873. Additional sidings were added in 1884 when the lime kiln was also built. Today, the 50 acres has been handed back, the manager's house is an attractive residence and the industrial buildings have been converted into holiday cottages.

Rolle Canal

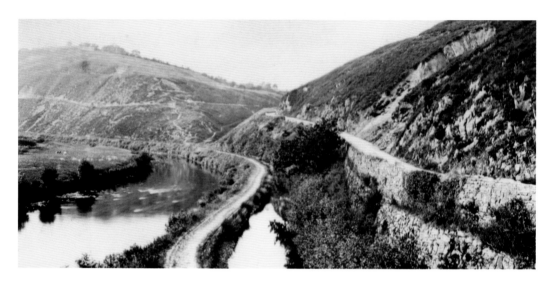

Rolle Canal, c. 1870

The canal was built to transport the lime required to increase the fertility of the acidic Devon soil. Devon's roads were narrow and deep in mud in winter, and it was treacherous for packhorses to negotiate the steep, muddy lanes. Rain caused the lime to burn through the pack saddles or carts. Boats transported limestone up the river to lime kilns but could only go as far as Weare Gifford. Then it was packhorses again to take it on to its eventual destination. The canal enabled limestone and coal to reach further inland to kilns at Rosemoor and Taddiport. The origins of the canal began at the end of the eighteenth century, when they were seen as the solution to many transport problems and 'canal fever' swept the land. In 1793, Denys Rolle chaired a meeting at The Globe and the idea was born. It would start with a lock on the river where it was still tidal and where there was a sharp bend, which would facilitate entry to the lock. Hundreds of navvies were employed to start at a number of sections along the route simultaneously, which must have been good fortune for the inns and public houses of Torrington. It eventually opened in 1827.

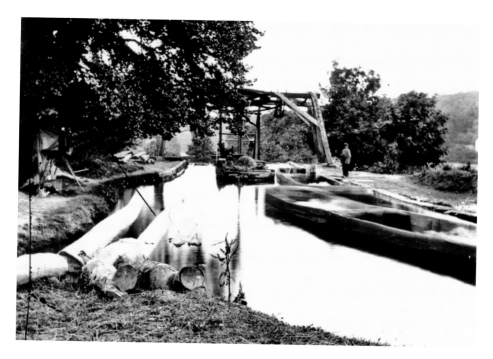

Top of the Inclined Plane, c. 1864

Two tub boats are lying in the upper basin of the inclined plane, probably having just come up, as the rear one has its bows pointed towards Torrington. The overhead gantry supports the large pulley wheel, around which the endless chain runs to which the tub boats are attached for ascent or descent. When the railway was built, it cut right across the basin at about the same position as the man in the picture, destroying the top of the underground chamber, which housed the waterwheel driving the chain. Very little evidence of the incline can be seen now, but the personnel entrance that enabled engineers to access the waterwheel for maintenance can still be seen at the rear of the basin.

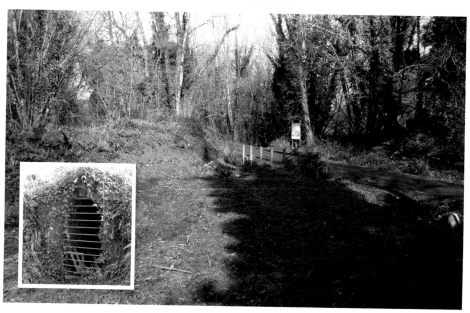

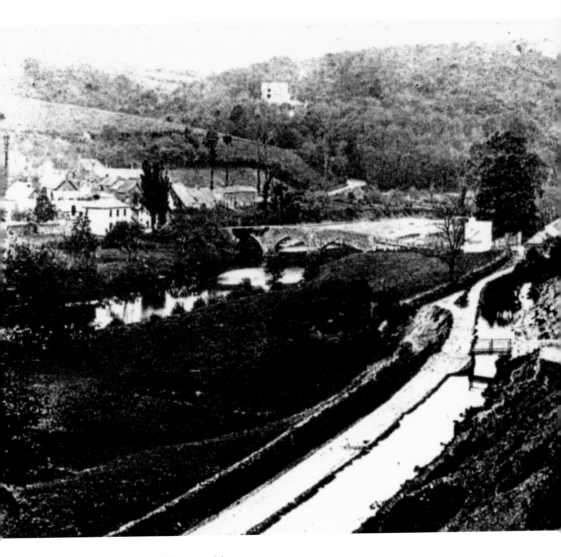

Rolle Canal and Taddiport Bridge

This is a very early photograph, as the Rolle Canal, which closed in 1872, is still in water with the accommodation bridge carrying the footpath coming down from the town still in place. The footpath route had to be maintained when the canal was built. The old toll house is just to the right of the bridge, and the Rolle Canal offices to the right of the toll house. On the far side of Taddiport Bridge is the old Buckingham Arms coaching inn hotel, where posting horses could be exchanged for the next section of the journey. The notice on the side of the building says 'Buckingham Stables'. The owner of the hotel has had to live on the first floor at times when the whole area flooded. On the far side of the bridge, the main road to Plymouth went straight up the hill, and the old road from Monkleigh ran parallel to the river past Servis Farm and came in at this junction. This saved crossing the river twice, here at Taddiport and at Rothern. The tower of the leper hospital chapel can be seen to the right of the hotel.

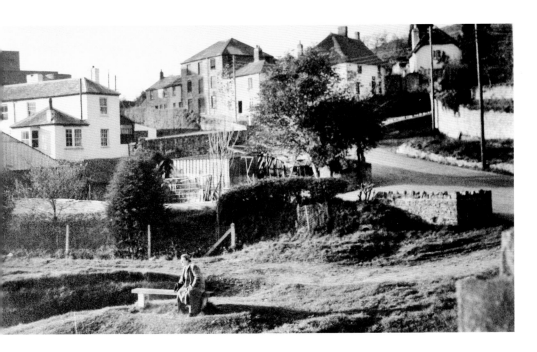

HQ of Rolle Canal, Taddiport

The bottom of Mill Street and of Limers' Hill by Town Bridge was chosen as the headqurters of the Rolle Canal; it was also conveniently adjacent to the road to Plymouth. Three lime kilns were built here around 1810 by John Lord Rolle and four later at New Town Mills. The limestone was carried from Sea Lock up the inclined plane and along the canal to all the kilns. The HQ was a hive of activity, with a double canal basin with coal stored for security on an island between the two. There were busy wharves and offices, warehouses, malt kilns, coal cellars, yards for storing bricks, slates and wood, a carpentry shop for hammering and sawing, blacksmiths working with their roaring furnaces and clanging anvils, and a boatbuilding yard in which barges and tub boats were repaired, all backed up by the heat and smell of the lime kilns. There were stables for the canal horses and the donkeys, which were used around the site.

Inns and Hotels

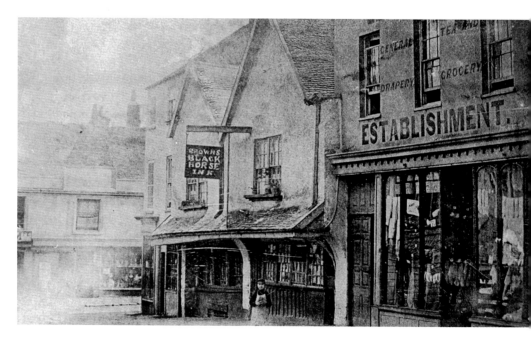

The Black Horse and the High Street, Looking North

The Black Horse is in the left foreground advertising itself as a 'Commercial Hotel'. It is an excellent example of what Torrington would have looked like in Medieval times. Before the serious fires and redevelopments of property in the town centre, Torrington would have been full of houses and shops looking like this. Here are two burgage plots side by side, built with the narrow gable ends facing the street to ration out the precious street frontage; their jettied fronts overhang the street.

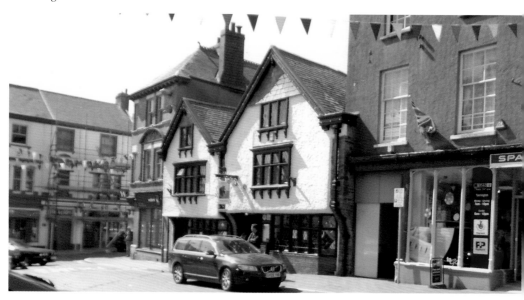

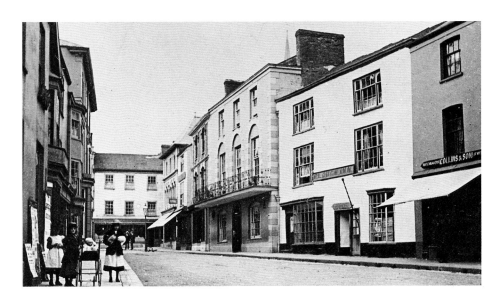

The Old Plough Inn, *c.* 1906

The second house on the right is the old Plough Inn, which probably began life as an elegant town house for a wealthy merchant. It had a beautiful plaster ceiling of strap work design and wood panelling from the late sixteenth century, and an ornate iron fireback bearing the Royal Coat of Arms, which is now in the town museum. Around 1750, this building became the Plough Inn, run by William Waldon, a maltster. In 1855, the town beadles and constables were entertained to a grand dinner there so it must have been an important inn. Only twenty years later, it was fast going downhill and complaints were made of 'the bad state of the closets and dung pit behind the Plough'. By 1911, it was in such a derelict state that the landlord of The Globe next door asked if he could keep his cow in there for a week. In 1912, the Plough, its stables and outhouses were demolished, and the Territorial Army drill hall was built in its place. The oak panelling, however, was saved and removed to the Council Chamber. The hall was used for badminton, concerts and hunt balls even after the Army had given up the lease in 1968. It became the Plough Arts Centre and the Royal Shakespeare Company even visited in 1978.

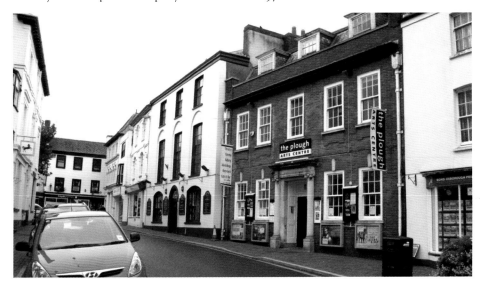

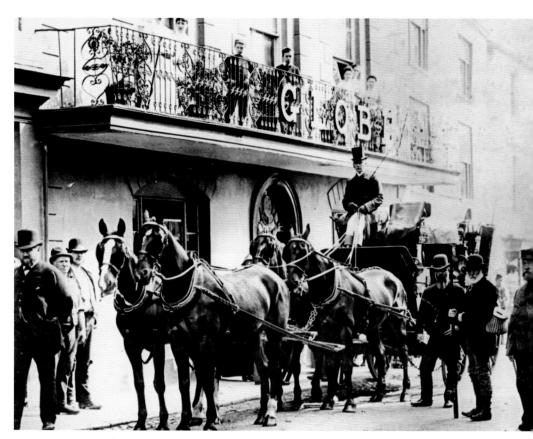

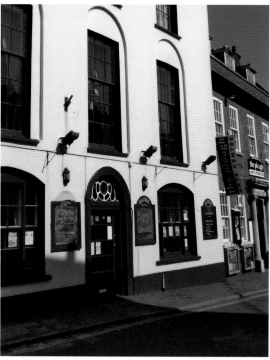

The Globe Hotel

The Globe Hotel, built around 1830, was Torrington's main hotel and posting house in the nineteenth century. Situated right in the middle of the town in the Market Square, it was always a grand venue, and in 1855 the Town Council was entertained to a grand dinner here when the beadles and constables were consigned to the secondary and less important venue next door at the Plough Inn. It has a magnificent ballroom with pillars and columns adorned with cupids, and large wine cellars under the hotel. In 1830, all the stage coaches called at The Globe and changed horses there if necessary, as it was a posting inn. In 1883, The Torridge Express left for Bideford at 5.00 p. m. on Monday, Wednesday and Friday. The N. Devon ran to Barnstaple of Tuesday, Thursday and Saturday, and to Plymouth at 10 a.m. on Monday, Wednesday and Friday.

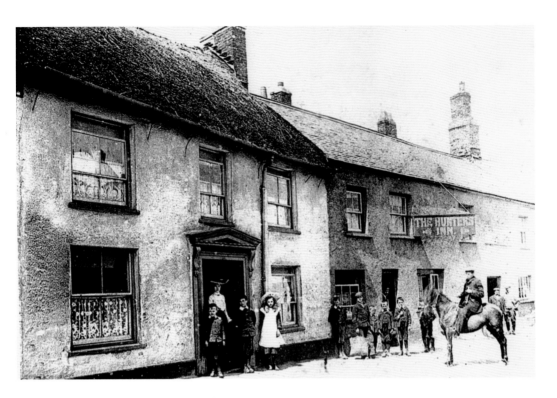

Hunters' Inn (Now The Cavalier), *c. 1890*

The first cottage on the left of the photograph is the Hunters' Inn, which had a pump outside, and was renamed The Cavalier in 1999. The next cottage along the street was demolished to form the car park beside The Cavalier. The tall house next along is the White House, but the next few properties after that were demolished to create a straight through route between New Road and Calf Street, thus replacing the tortuous link along little Rosemary Lane that had existed before.

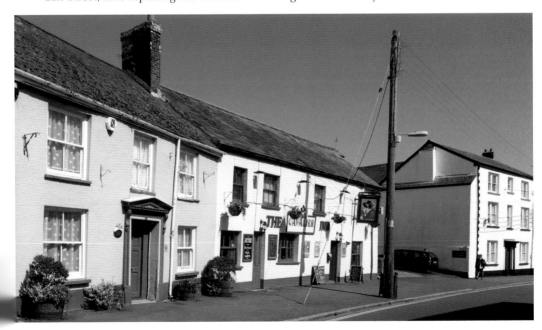

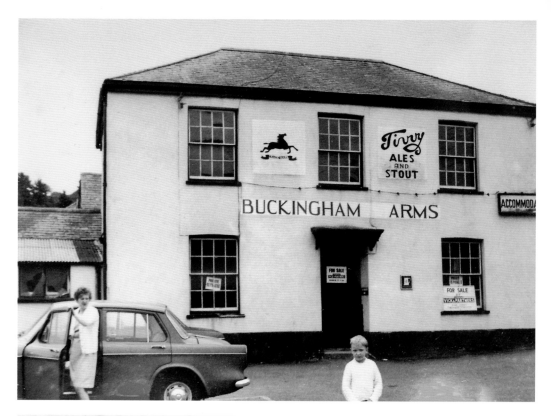

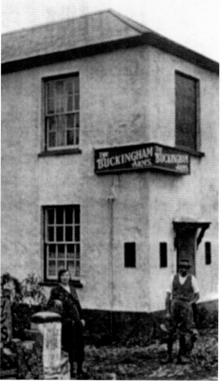

Buckingham Arms, Taddiport

The Buckingham Arms, seen above in 1970, was formerly a large coaching inn with capacious stables and a big yard at the back. In 1850, Ann Wilson is recorded as being the victualler here, but the picture to the left from 1920 is of later owners, Mr and Mrs Ash, standing outside. On the side facing Watery Lane, the sign still says 'Buckingham Stables'. Not only was it sited on the main route to Plymouth and Hatherleigh from Torrington, but it was also at an important hub and meeting point for roads going off in all directions: north into Torrington and Mill Street, south to Plymouth, south-west to Langtree and Cornwall, and along the Servis road to Drummetts Mill and on to Bideford without having to cross the River Torridge twice over. The pub was empty from 1966 to 1970 after Whitbreads took over from the previous owners, Starkey, Knight and Ford. The next owners opened livery and riding stables till 1987. It has suffered grievously over the years with problems from the river flooding. In the 1970s, the floods came almost up to the ceilings of the ground floor, tore up floors, destroyed furniture and books, and the owners had to move upstairs.

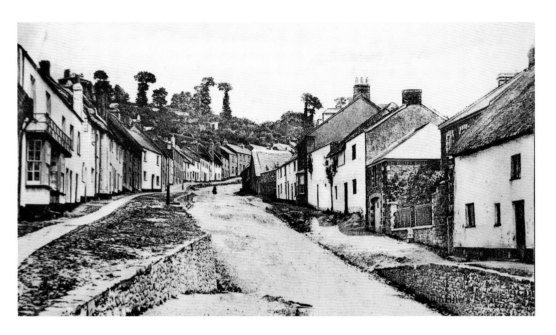

Canal Tavern

The first house on the left of the photograph, No. 120 Mill Street, was the Canal Tavern, which was situated close to the busy, noisy canal at the bottom of the street. It closed in 1850 and became a private house, but caught fire in 1859 in the chimney flue. The thatched roof burned uncontrollably and so rapidly that it suddenly crashed down on the poor occupants who were desperately trying to salvage furniture. They were badly burned.

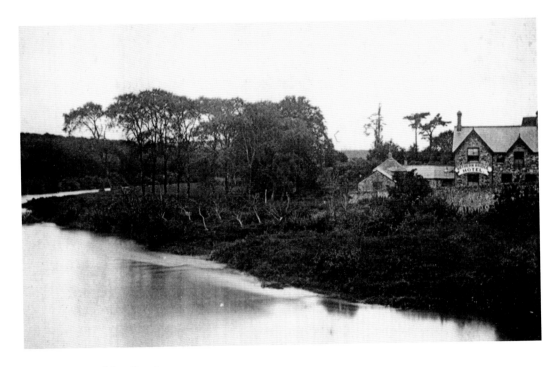

Old Rothern Bridge Hotel

This old house was built *c.* 1873 at around the same time as the railway arrived in Torrington, which was then the terminus of the line from Waterloo. For some years, it was run as an hotel and, being only a few yards from the station, was very convenient for people arriving by train. It was also right on the banks of the River Torridge and was known for its summer sea trout and salmon fishing. Surprisingly, the hotel only lasted for about a decade before it was taken over by the Rolle Estate to provide kennels for the Stevenstone Hunt and a house for the Master of the Hounds. Before this time, hounds and hunt employees had been based at Stevenstone itself.

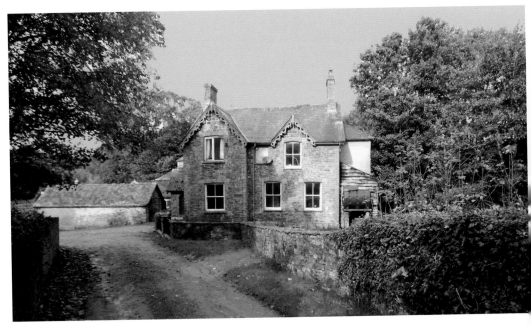

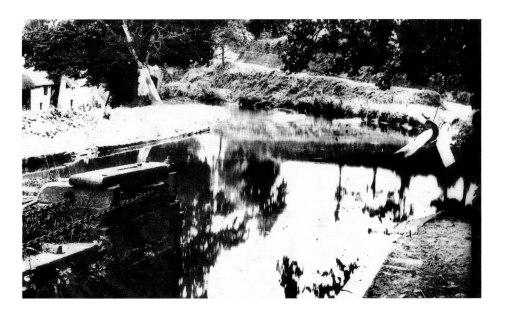

Hunters' Inn, Top of the Inclined Plane, Rolle Canal

North Devon Journal, 1833: 'On Monday last, public house near the inclined plane on the new Torrington Road called The Hunters' Inn was burned to the ground'. Fire had spread from the chimney flue of the copper in the brew house where the landlord was making beer. The inn was rebuilt as a stone building and it was much used by the workers from Ridd and Annery kilns and the canal. The picture shows the top of the inclined plane looking back towards Torrington. The inn is on the left of the picture, with the plane keeper's cottage next to it. The associated stables and outbuildings were on the right and the ruins of all these buildings can still be found there. The bridge across the canal connecting the new Torrington Road to the Inn and Ridd lime kilns can also be seen. The line of the canal basin is apparent in the recent picture, which also shows how the railway (now the Tarka trail) cut right across the underground waterwheel which powered the inclined plane.

Country Houses

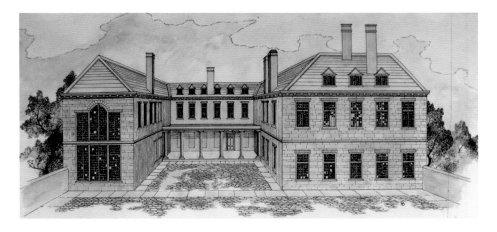

Great Potheridge and George Monk

The Le Moigne family (French for monk) came over with William the Conqueror, and owned Great Potheridge from the time of Henry II. It was only a fairly modest manor farmhouse when George Monk was born there in 1608. By the time he died in 1670, it was a palace. He was regarded as a national hero and the saviour of the monarchy, and had been given a peerage, vast tracts of land, and a state funeral. During the Civil War, he backed the Royalist cause as a general, and was imprisoned in the Tower of London for being on the wrong side. However, he did meet his wife, Nan, there. After the war, he was Commander of the Navy, defeated the Dutch and was covered in glory. After the Great Plague and the Great Fire of London, Monk was appointed to govern London. He died with no heirs, and in the 1730s the house was badly damaged by fire. The surviving remnant was converted into a three-storey farmhouse, but features remain from the original palace: the magnificent staircase, mantel shelves and chimney pieces, painted ceilings and the panelled dining room. It is a fascinating remnant of another beautiful house lost to the area.

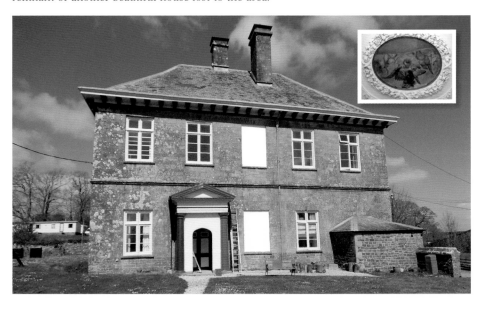

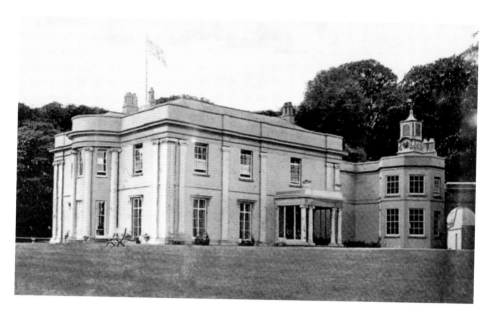

Annery

The old former house in the photograph was built in 1800. When the Annery went up for auction in 1912, it had 422 acres fenced around, four drives and lodge houses, fishing rights on the Torridge, the Dower House, Beaconside (later to be an hotel), many farms and cottages and a corn mill called Landcross Mill. Annery had its own aisle with its own pews and own private entrance for the household n Monkleigh church. The four reception rooms and the library were spacious; there were twelve bedrooms, three staircases and a clock tower and bell tower (shown in the picture). Outside were salting houses, a dairy, a cider cellar, laundries, coach houses, a potato house, apple room and two cider houses. As well as domestic wells, an automatic ram pumped water from the stream at Landcross Corn Mill to a huge reservoir at Beaconside in case of fire. There were tennis and croquet lawns and a kitchen garden with 12-foot high walls, a vinery, peach and nectarine houses and hot houses. It even had its own private platform on the Bideford to Torrington railway line. By this time, the splendid Dower House was referred to as The Bungalow, despite having six bedrooms and a schoolroom on the first floor and a stable and carriage house. Here lived the head gardener with his family in splendid style.

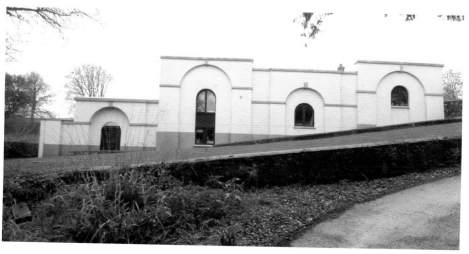

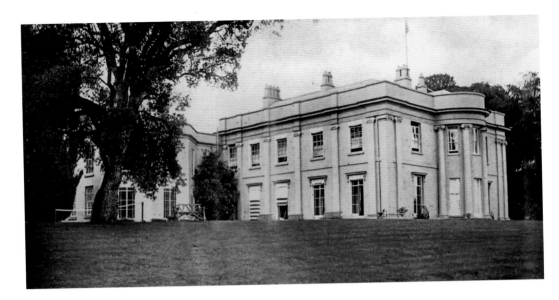

Annery

The Annery site is ancient, first recorded in 1193 as Auri, as Anerie in 1238 and as Upanry in 1332. By 1260, it belonged to the Stapledon family where Walter Stapledon, later Bishop of Exeter, was born. The last Stapledon owner and the heiress of the estate was Thomasin, who married Sir William Hankford. He became Lord Chief Justice of England, but is most remembered for being shot dead in 1422 by his gamekeeper. By 1810, it was owned by William Tardrew, who operated a shipyard down on the River Torridge next to Annery Kiln; he later leased the Rolle Canal from Lord Rolle with some others and then moved his shipbuilding to the Sea Lock on the canal mouth. The last owner to live in the mansion was Lilias Fleming and her adopted daughter, Crystal Fleming. When Lilias died in 1941, nobody lived there again. Prospective buyers stayed in the Dower House and the main mansion deteriorated quickly. Despite being one of the most splendid and attractive mansions in North Devon and being Grade II listed, Annery was abandoned and finally demolished in 1958 to be replaced by a bungalow, though the beautiful Dower House remains as the main house on the estate.

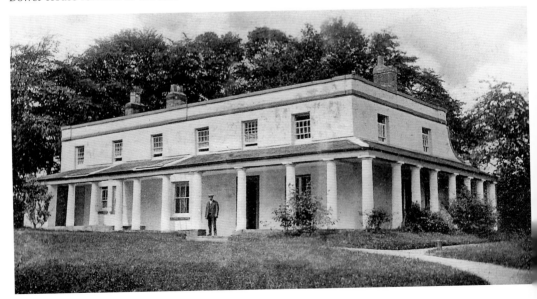

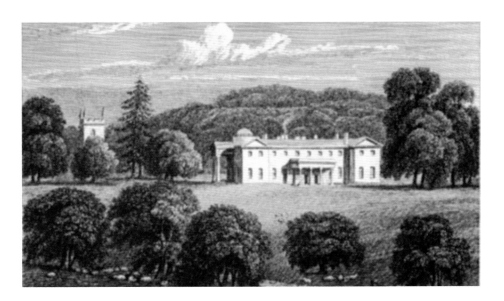

Buckland House, Buckland Filleigh

This ancient estate was given to William de Punchardon by William the Conqueror. It came into the Filleigh family of South Molton by marriage, and then by another marriage in 1454 to the Fortescue family and stayed in that family until the 1880s. Buckland House came to the Fortescue family through a propitious marriage in 1454 and it stayed in that family until the 1840s. The house is early Georgian, built around 1710. Sadly, the original house burned down in 1790 and was rebuilt on a grand scale in 1810, including sinking the lane in front of the house. The rebuilding costs bankrupted the unfortunate Fortescue who had inherited it. Tragedy struck again in 1952, when Percy Browne inherited the house only to lose his wife in a terrible hunting accident in the same year. He lost heart then, divided up and sold the estate, and it became Buckland House School, which lasted until it closed down in 1984. Now it is used as a splendid self-catering country house for twenty-seven people, and for weddings.

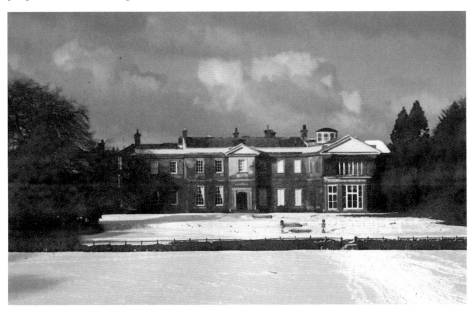

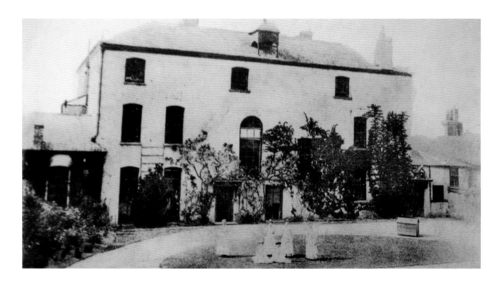

Cross House

Cross is a very old site and is known to have started life as a medieval hall house. In 1740, it was rebuilt for Christiana, the daughter of Lord Rolle, and her husband, Henry Stevens. The Cornish mansion of Stowe built for John Grenville was being completely demolished at the same time and auctioned off, and all the architectural features were saved from that old house and incorporated into the new build at Cross. This included the doors, the windows, the magnificent elm staircase complete with putti in the style of Grinling Gibbons, carved mantelpieces, plaster ceilings, and many rooms of beautiful carved panelling, which were altered to fit the new house. In the late eighteenth century, Henry Stevens of Cross House was particularly intolerant towards nonconformity, and was involved in an unseemly brawl. A Methodist preacher called Richard Drew came to preach to the residents of Taddiport in a courtyard there, but Henry Stevens, despite being a magistrate, was infuriated by him, pulled him roughly off his chair where he was standing and exhorted the crowd to throw him into a quarry pit. Stevens was reported to the Court of the King's Bench and subsequently felt so ashamed of his behaviour that he left Cross House forthwith. It was left unoccupied for thirty years.

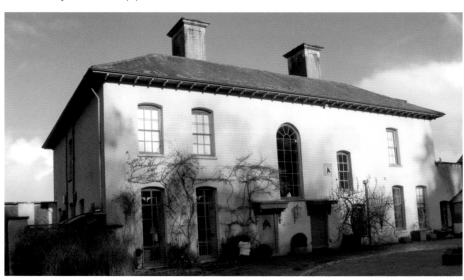

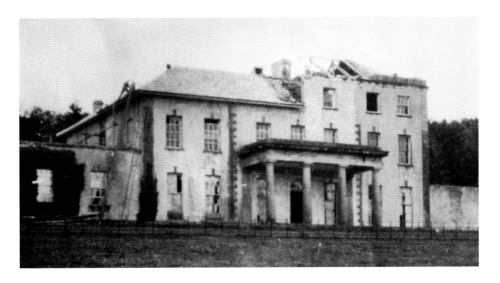

Cross House

In the 1820s, the house was enlarged and a third storey added, together with a huge Dartmoor granite portico, and a second driveway built down to the Langtree road. Capt. Stevens-Guille, who lived here in the early part of the twentieth century and lived the life of a leisured country man, liked to signal from the top storey at Cross to his friend on his top storey at Port Hill in Northam, a distance of 8 miles. In 1937, however, the top storey was removed from Cross (as shown), and the days of signalling were over. At the same time, the single-storey wings on either side of the house, which had housed the kitchens in the east wing, and the stables and brew house in the west wing, were also removed. Like so many other big houses, Cross was requisitioned in the war and troops were billeted here, but the water supply was so limited that it had to be transported here in carts and this severely limited troop numbers. It stood in a good strategic position, though, and searchlight batteries were stationed in the area. In the second half of the twentieth century, Lady Fisher lived here, but after she died it again lay empty for many years and was burgled. Recently, however, it has been lovingly restored to a gracious family home.

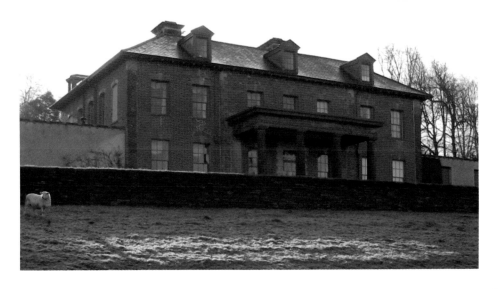

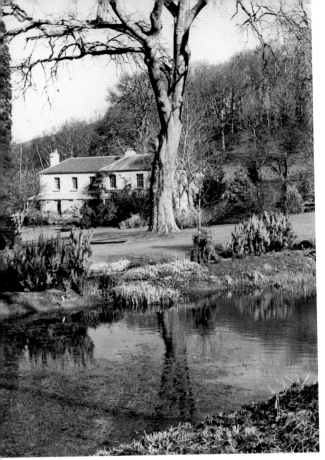

Rosemoor House and Gardens

Originally, the area was called Rowe's Moor, and the house, which was built in the 1780s, belonged to the Rolle family. Lady Anne Berry's family bought it in 1924 as a fishing lodge, which they only used from March to May. She was a descendant of Sir Robert Walpole, Britain's first prime minister, so getting things done was in her genes. She never went to school, but had an amenable governess from whom she found it easy to escape, to ride her pony and go hunting. In 1931, Lady Anne moved to Rosemoor permanently and, together with her mother, took the garden in hand and began creating the beautiful landscaped gardens we see today. However, the house was requisitioned in the Second World War and used by the Red Cross for London's East Enders affected by the Blitz. After the war, her husband bought more land and started a dairy farm. (*Photograph on the left by Denzil Bath*)

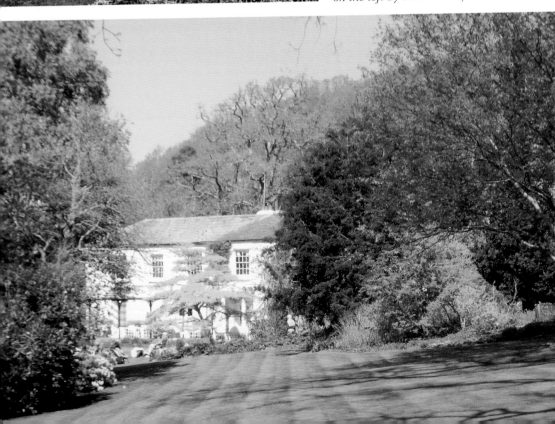

RHS Rosemoor

Lady Anne Berry had measles very severely at the age of forty and went to Algeciras in 1959 to convalesce. There, she suddenly discovered a great interest in plants and began a collection that led to her serious development of her garden at Rosemoor, where she opened a small nursery. In 1988, she offered Rosemoor and its 8 acres of garden, together with 32 acres of farmland, to the RHS as a magnificent gift, and only two years later RHS Rosemoor was opened. Although RHS Rosemoor lies in a particularly beautiful valley, it has heavy clay soil and the site was split by a road. However, the whole project has been an unmitigated success, with its beautiful stream-side gardens sloping down to a peaceful lake, and it has managed to maintain perfectly the character of the old established gardens around the house.

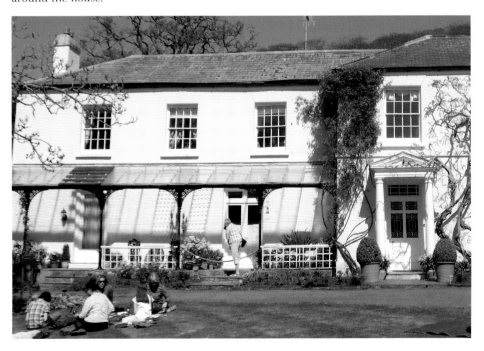

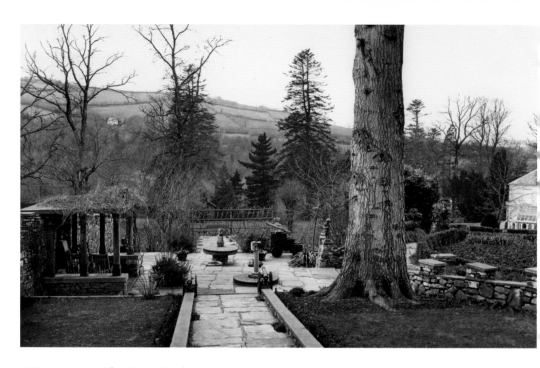

RHS Rosemoor, The Stone Garden

When Lady Anne moved to Rosemoor permanently with her mother, she described the existing garden as 'dull and typically Victorian', with beds of annuals round the house. This Stone Garden was designed by Lady Anne's Mother and was the first area of formal landscaping that they created. In the spring it is a mass of colour from mature camellias and spring bulbs. In 1990, Lady Anne was married for the second time to a New Zealander, Bob Berry, and moved there to live, where she helped create Hacksfalls Arboretum with over 1,000 specimens. (*Photograph above by R. L. Knight*)

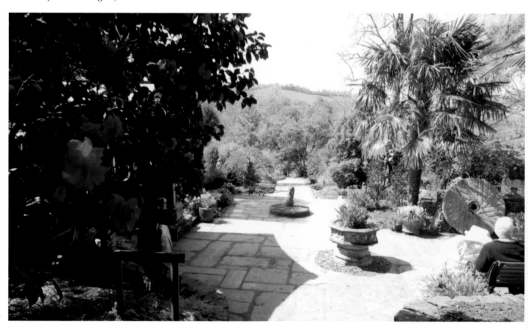

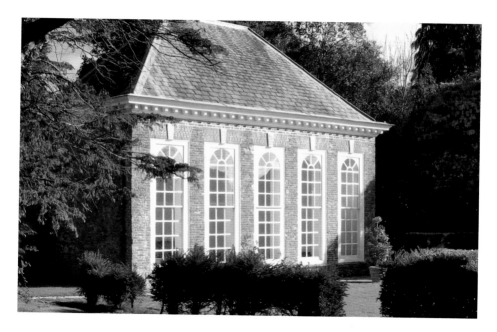

Stevenstone Library and Orangery

From the sixteenth to the nineteenth century, Stevenstone was the North Devon seat of the Rolles, the largest landowners in Devon. Certainly, three succeeding mansions were built on the site, the second one a remodelling of the original Tudor brick house, which was built at the same time as the library and orangery and probably dated from around 1680. When Stevenstone was rebuilt in 1868, the Orangery was reroofed in glass and became a fernery, following the fashion of the time, as the Victorians loved ferns and aspidistras. In the 1940s, the library was converted into a house, and the fireplace from the dining room in the main house was installed in its drawing room. In 1978, both buildings were offered for sale in a dilapidated state and both were bought by the Landmark Trust, who carefully restored them and offered them as holiday cottages.

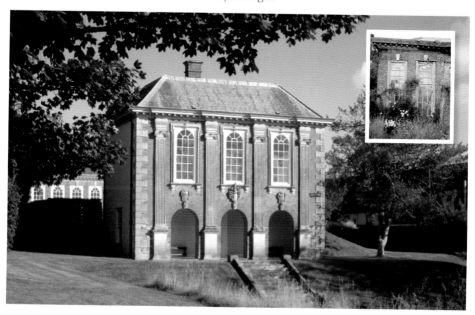

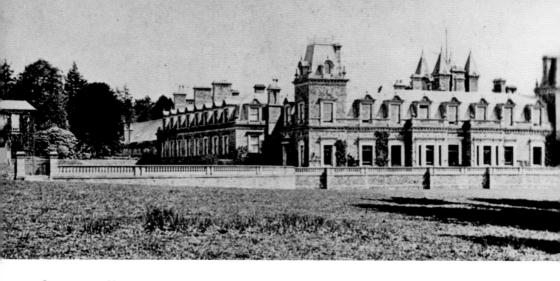

Stevenstone House

Resembling a French chateau, this was by far the largest and grandest house in North Devon, with its steeples, turrets, towers and balustraded terraces. Sadly, it is now nothing but a romantic ruin. Six lodges still survive, which once stood at the ends of long drives. In 1868, Mark Rolle began building his magnificent new edifice to replace an earlier square manor house, which was certainly in existence by 1309 when a licence was granted to hold services in its chapel. He added magnificent stables, carriage houses, workshops, sawmills, a huge walled kitchen garden, a 50-foot-long billiard room and a tunnel under the terrace so that gardeners could work unseen. In 1907, the massive chateau was reduced to a mere twenty-seven bedrooms. By 1930, it was being offered at auction with 665 acres, a deer park, fishing lakes, an engine to provide electricity, gas engines to make acetylene gas, a large stable block and garaging for ten cars. But it didn't sell and the magnificent fixtures and fittings, the marble fireplaces, the oak panelling, carved staircases and doors were all sold off piecemeal. During the Second World War, the house was requisitioned for British and later American troops, in spite of its being an empty shell. Life inside must have been bleak indeed. Afterwards, the house gradually fell into ruin and more building materials were stolen from the house. Bungalows were built in the huge walled kitchen garden.

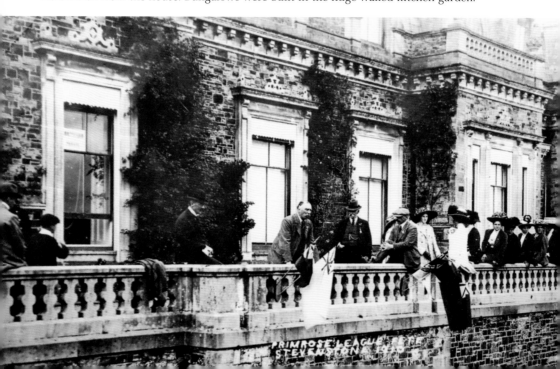

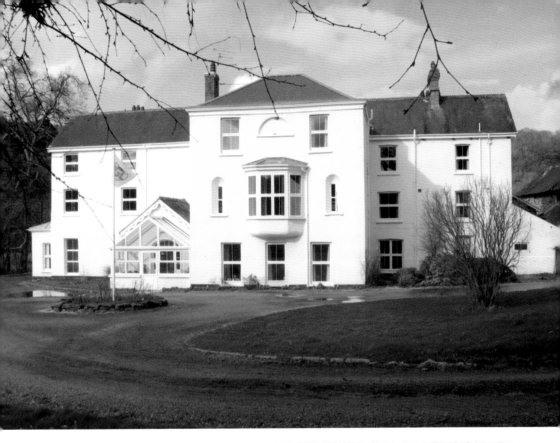

Beam House

This old house has had a long history. It was a subsidiary house of the Rolles, whose main house was at Stevenstone. During the Civil War, it was used as an outpost for the Royalist army, as it was right by the River Torridge. Denys Rolle was born here in 1725 and lived here until 1797. Then Joseph Palmer (1749–1829), son of John Palmer, lived here with his wife, Mary, sister of Sir Joshua Reynolds. The main carriage drive was from the Weare Giffard road, though very old maps show a hazardous secondary drive that led down to the river and attempted to cross it downstream of the weir to continue up the hill to Plumper's Bridge and Monkleigh (now gone). This main carriage drive was later interrupted, first by the canal being cut through and later by the new railway line, so two bridges had to be constructed to cross them. The old canal route is shown on the map. In the First World War, Beam was requisitioned as a convalescent home for injured soldiers and is now an adventure school, PGL.

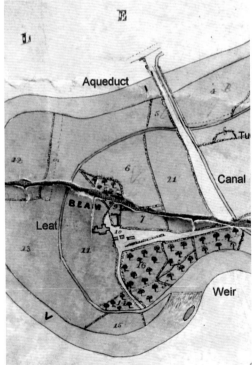

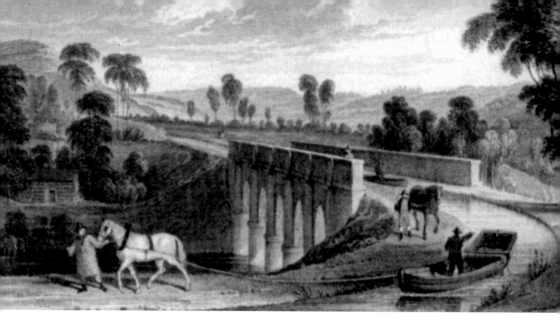

Beam Aqueduct

James Green, the engineer, planned a route on the east side of the river but this required an aqueduct, shown in this well-known engraving of the Rolle Canal crossing the River Torridge at Beam. On 13 August 1824, the *North Devon Journal* reported, 'The Right Hon. Lord Rolle partook of a public breakfast with the Corporation of Torrington and the major part of the genteel Inhabitants of the Neighbourhood and afterwards proceeded ... to Beam House ... for the purpose of laying the Foundation Stone of an Aqueduct ... strong beer was given to the populace, and the whole of the day was one of great hilarity.' At the far end of the aqueduct, the canal crossed over a much smaller arch, which spanned the leat, supplying water power for a small tucking mill nearby. Interestingly, this tucking mill can be seen in this picture as the small building on the left. The leat went on from here to feed the mills at Weare Giffard. After the canal closed, the water trough that took the canal over the aqueduct was filled in and became the main drive from Beam House to the new Torrington to Bideford Road.

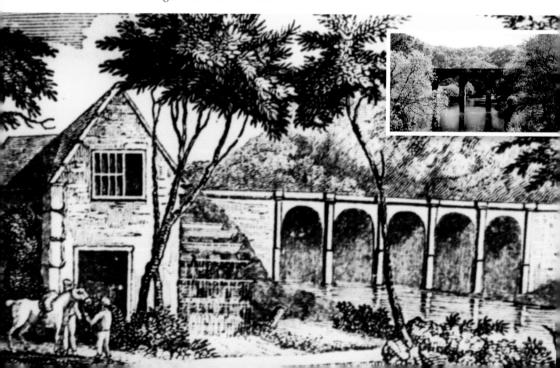

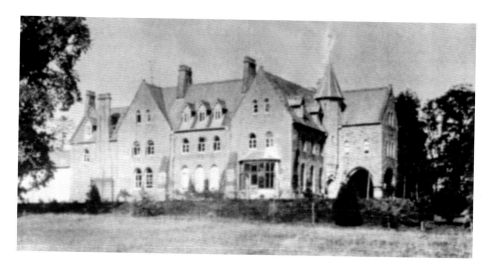

The Lost Mansion of Winscott, Petersmarland

Winscott was a Domesday manor house in 1086, which became the seat of the Stevens family who also owned Cross House, Little Torrington. By 1850, John Moore-Stevens owned the house and he built (or rebuilt) a most splendid mansion on the site in 1865 using the yellow Petersmarland bricks from the nearby Marland clayworks. He grew up expecting to be the heir of the 1st Baron Rolle of Stevenstone, who was childless, and was most disappointed when Lord Rolle left his immense fortune to Mark Trefusis (who changed his name to Mark Rolle). John Moore-Stevens was a JP and MP for North Devon, so he built his splendid new mansion with its own Magistrate's Room, complete with waiting room and separate entrance. His son shut up Winscott and moved to Exeter in 1920, only fifty-five years after it was built. The house was left unloved and unwanted and empty until it was demolished in 1931. Today, there is nothing to show that the magnificent great mansion ever existed, except for a flattened area in a meadow and the lodge and imposing entrance gates. All traces of the house, walled gardens, orchards, terraces and tennis court have vanished as though they had never been.

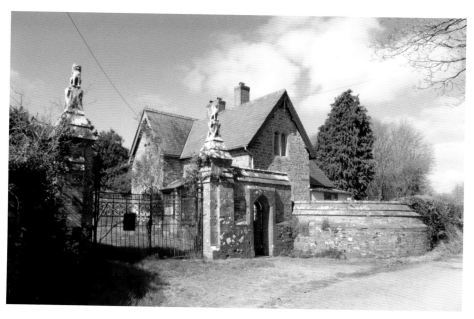

Hospitals, Churches, Schools & Castles

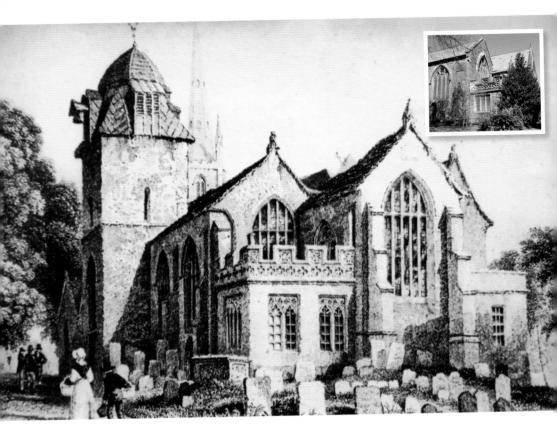

Church of St Michael and All Angels

The castle had its own chapel and chantry priest from 1278; the town had the church of St Michael, with a priest appointed by 1279. Margaret, Countess of Richmond, the great benefactor to Torrington, owned the moated manor house, which was on the site of the old vicarage. She gave the church a magnificent library within the church, and even in 1830 it was still described as having a library. In 1510, the man who would become Cardinal Wolsey was given the living. Huge damage was done to the church in the Civil War when eighty barrels of gunpowder stored there were ignited, but it is thought that parts of the church did survive the disaster and the ruins were repaired. A door in the east end of the south aisle leads into the Tudor Room (now the vestry), and quite possibly Margaret's library and the exterior of this room is richly and beautifully carved, in contrast with the severe plainness of the rest of the building. At the Reformation, some townspeople were found to have sold 'juells and vestments (three copes of blew velvett)' instead of handing them over to the Royal Commissioners as per instructions. The tower in the old picture survived till the early nineteenth century, but in 1830 a new tower was built at the west end instead. There were galleries on all three sides, removed in the 1860s together with the old sounding board above the pulpit. For a long time, it lay neglected in a builder's yard, until it was rescued and given to the V&A, who returned it in 1860.

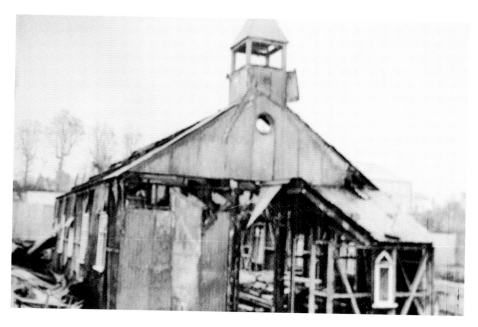

Iron Church at Goose Green

Many local people remember Goose Green Garage on Calf Street, which was sold to developers some years ago and now forms the entrance into a housing estate just before the Cottage Hospital. The site of the garage was once a church made of iron called St Gabriel's Mission church. These 'tin tabernacles' could be bought in kit form from catalogues and were prefabricated churches made of corrugated galvanised iron, which could be assembled quickly and cheaply to accommodate expanding populations. They only cost £150 for a chapel seating 150 people, and by 1875, hundreds of them had been built. The top photograph shows it being dismantled before being moved to Westward Ho!, where it was re-erected and used as a church until the parish church was built, and later used as tea rooms called Lewis' Café. This unusual old building remains there to this day in Station Road, Westward Ho!, and is now a restaurant.

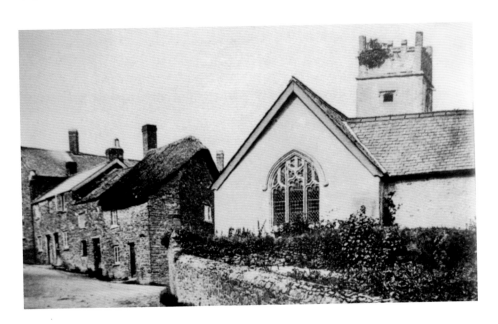

Taddiport and the Leper Hospital

In the Middle Ages, there were twenty leper colonies in Devon. They were called hospitals even though they were built to isolate infected people. The hospitals usually had an adjacent chapel with a priest, and tended to be built well away from any nearby town or village, hence the position of this building on the far side of the river. Strict rules were enforced preventing the lepers from attending markets, mills, churches, bakeries or even from passing through narrow lanes in case they inadvertently touched somebody else. They were only allowed to wear distinctive leper clothes, a cloak with a hood and with a bell attached to their belts, and were always to wear shoes and gloves. Their tiny chapel, though altered somewhat over the years, is a remarkable survival, with its chapel bell to call the lepers in to meals from the narrow field strips where they spent their day at work. To be isolated here away from everyone else, probably forever, must have seemed like a death sentence. Most of their food was grown in the narrow leper strips, but some would probably be left for them by the ancient bridge so that they never needed to approach the town.

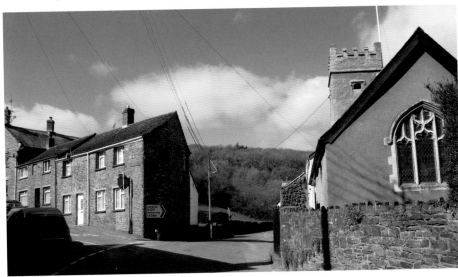

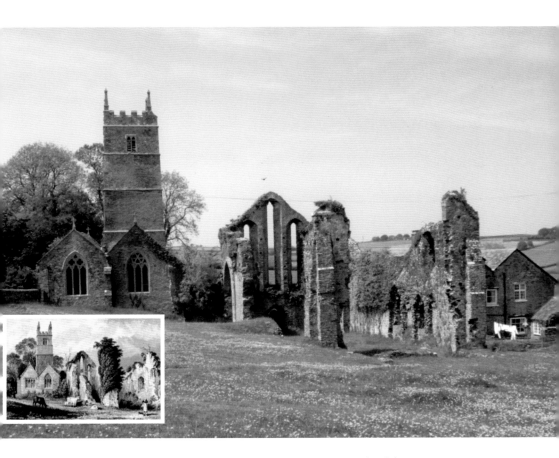

Frithelstock Priory and Why the Prior Put His Tongue Out At His Bishop

The Priory was founded in the 1220s as a daughter church of Hartland Abbey, one of seventeen in Devon before the Dissolution. Sir Robert de Beauchamp set it up to intercede for his soul in Purgatory. The monks farmed 500 acres, and by 1333 it had a prior, thirteen canons and two seculars. The canons built a chapel in a nearby wood 1 mile away called 'Waddycleve' dedicated to the Virgin Mary, with an altar and an image of her. Pilgrims flocked to this chapel of Mary in large numbers and doubtless made large donations too. Unfortunately, the prior had not bothered to ask Bishop Grandisson to consecrate or license their new chapel and he ordered the prior to destroy the chapel on pain of excommunication. The canons wrote back hastily that this had duly been done. But in the late 1700s, when all chapels were being recorded, there is a note saying, 'Frithelstock, on a tenement called Waddecleve is a dwelling house which goes by ye name of ye Chappell, one mile from Priory' (now called Mount Pleasant). There is a carved bench end in Frithelstock church that shows the bishop and the prior sticking their tongues out at each other. In 1340, Bishop Grandisson visited and was not best pleased with what he found. He ordered the prior to take his meals in the refectory with the rest of the brethren and sleep in the common dormitory and receive all his vestments from the common store. The humiliated prior was sent to do penance for a time at Hartland Abbey. In 1353, John Heyncie was elected prior and when he resigned, pleading ill health, he was given a private room and awarded three large cheeses, 10 lbs candles, two cartloads of fuel, twenty-one loaves, 24 gallons of better beer and food for his servant annually. The Priory closed in 1536, by which time only five canons were in residence. Both pictures show the drive at Woodland Vale. Once a workhouse, the bleak, old building was demolished in the 1990s to be replaced by a new care village. The snow of 1962 has been replaced by snowy cherry blossom.

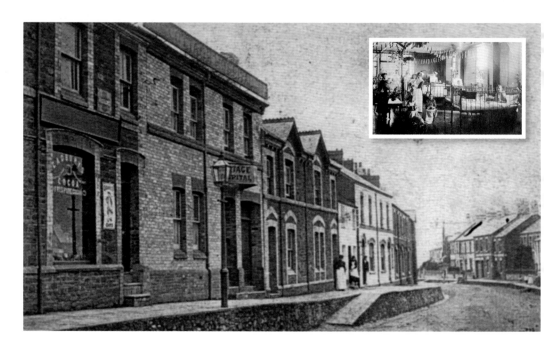

Torrington Hospital

Remarkably unchanged, the hospital was established in 1898 at No. 181 New Street, the Marland brick house opposite Lidl. William Vaughan lent the house rent free to the town. The mortuary yard was next door. Hospitals were not much used at that time, except by poorer people, as most were treated and nursed in their own homes. Even operations were mostly carried out at home. Not too many hospital acquired infections then, though hygiene was a big problem. In 1907, land was given at Goose Green by the Hon. Mark Rolle and the new hospital opened in 1908. It had wards for men, women and accidents, each with three beds and a cot, and there was an operating room, a surgery, a consulting room and the matron's apartment. In 1939, four more rooms were added for private patients and these rooms later became the maternity ward. During the world wars, many wounded soldiers were treated in the hospital.

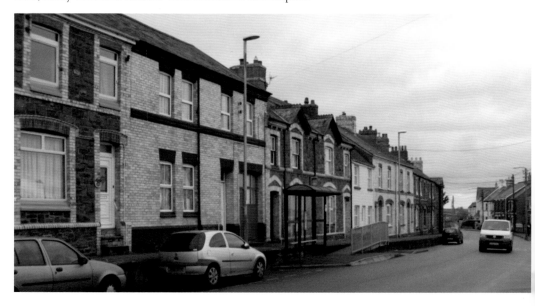

The Blue Coat School

The school was first opened in the Chantry chapel of St James, which had belonged to the castle in the fifteenth century and was mentioned in 1485 as 'La Scolehouse'. Writing around 1620, Risdon says of the castle 'there remaineth only a chapel with the scite now converted into a School House'. By the 1770s, the old building was so deteriorated that it was certainly partly demolished in 1780, and the children were moved to the town hall until major structural alterations and repairs were made to the old building and the children were able to move back. The school was probably rebuilt by John Lord Rolle of Stevenstone in 1834, on the site of the medieval castle chapel, to educate poor children of Torrington; it was also known as Barley Grove School, a Church of England school. It only had three classes so the classes were mixed ages. There it remained until 1978 when it joined up with the Board School in White's Lane. The White's Lane School was built in 1872 and it had a swimming pool on the site of the Memorial Garden by Castle House.

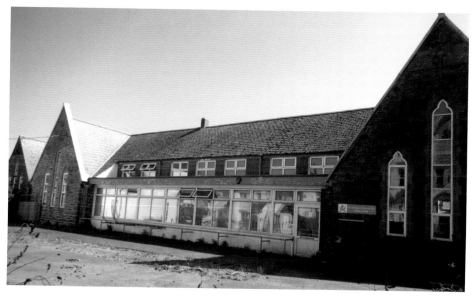

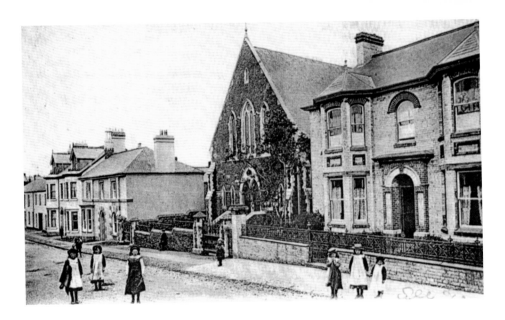

The Castle and Castle Street

This ancient street ran between the site of the town's castle, first recorded in the twelfth century, and its medieval market, and would have been used to fulfil the needs of the castle. By 1540, John Leland wrote of the castle 'nothing remaineth standing but a neglect chapelle'. Torrington's ghostly castle and its remnants, so much part of the character of the town, are intriguing. The name Barley Grove is probably a corruption of bailey (the open courtyard area inside the castle walls where the kitchens, guardrooms, stables and storerooms would have been sited). The castle's chantry chapel became one of the town's first schools, the old town pound was within the castle site, and the grassy mound by the bowling green is believed to be the remains of the castle motte. The remnants of the castle walls were found below ground when the bowling green pavilion was being renovated. The Barley Grove car park has long been a big empty site and historians consider that it may have been the castle's tilt or jousting yard.

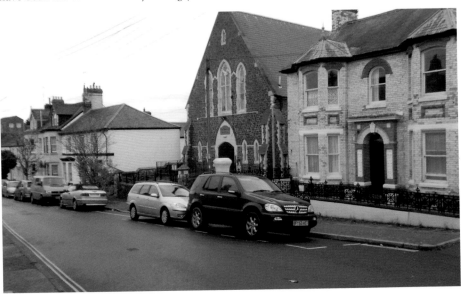

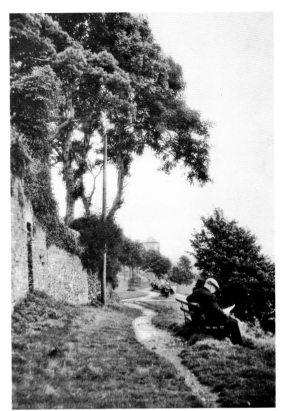

Castle Walls

Probably author's licence to call these castle walls, but it is likely that John Lord Rolle would have looked for evidence of the original in 1846 before building a simulation on the escarpment. The result is one of the most attractive features of Torrington, with a tranquil setting overlooking the Torridge valley and the network of fields on the opposite bank. A century ago, sheep would have grazed the commons below, but now the cropped grass has been replaced with bracken and trees.

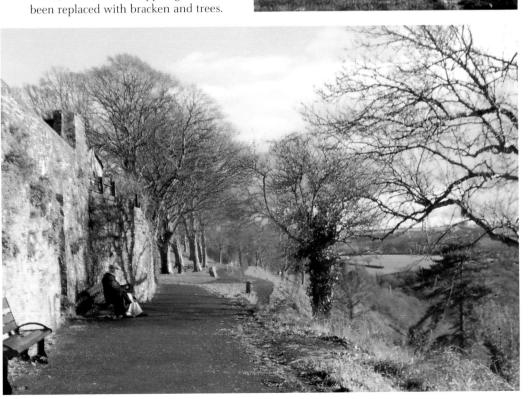

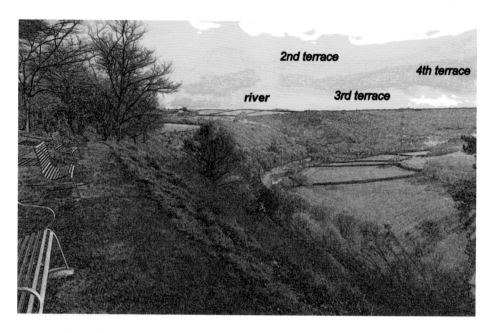

Castle Hill Landform

The castle was built at Barley Grove above this particular site to take advantage of the defensive position of this almost vertical cliff face, which drops precipitously down below it to the River Torridge and forms the north bank of the river here. The sliding stone feature on this path is an excellent exposed example of the rock within this cliff, which is of Bude Formation sandstone. These were sedimentary rocks laid down around 310 million years ago on the floor of an ancient sea, which were later folded by massive forces from a horizontal position to an almost vertical upright one. Below, in the valley, are the remains of five terraces that display the ancient former positions of the River Torridge.

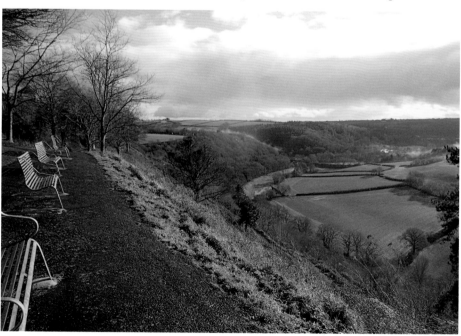

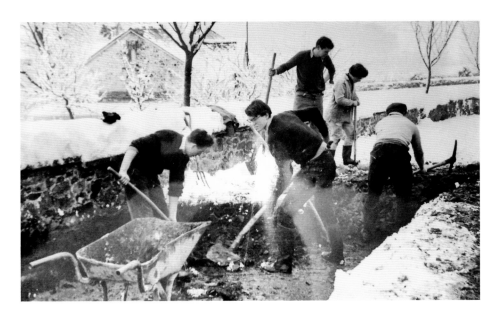

Hard Winter at Torrington, 1962/63

With temperatures so cold that the sea froze in places, the long winter of 1962/63 was the coldest since 1683. Temperatures plummeted alarmingly and rivers and lakes froze over. Cold continental winds from Russia were drawn in, heavy snow fell on 26 December and the bitterly cold air became firmly established. On 29 December, a fierce blizzard swept across South West England, and snow drifted to over 20 feet in places. Whole villages were stranded and cut off for weeks, people could walk across the tops of high Devon hedges, power lines were brought down, and roads and railways were blocked. Food drops had to be made to stranded starving animals, and distressed, frost-bitten soldiers had to be rescued from Dartmoor. The long spell of sub-zero temperatures kept the snow frozen and hard for over two months; the country was frozen solid and metre-long icicles hung from roofs and gutters. The weather that year was so cold that water pipes froze and Stevenstone Lake became a skating rink.

Shops

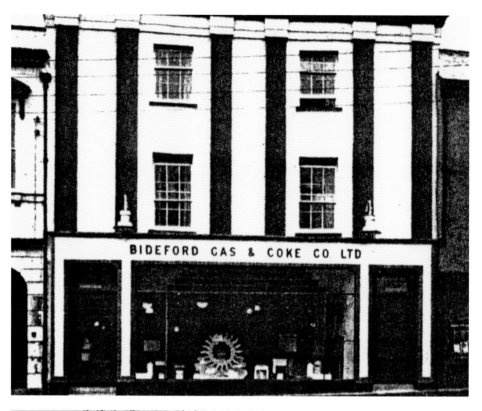

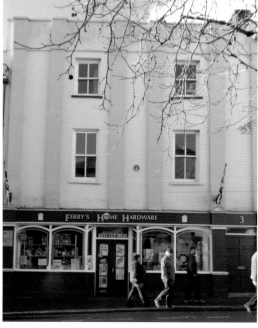

**Bideford Gas & Coke Co.,
No. 3 High Street**
Now Ferry's Home Hardware
Store, this shop is on the site of
part of an old tannery, which
extended right back to where
Tannery Row is now in Church
Lane. Situated right in the
middle of town, the appalling
smells of the stagnant old
urine and dyes in the tanning
vats must have been a problem
for the residents around, and
most other towns kept their
tanyards well away from the
town centre or downwind of it.
The premises were later rebuilt
to become a gas and coke shop,
as in the old photograph. This
was followed by Sing and then
by Powe furniture shop.

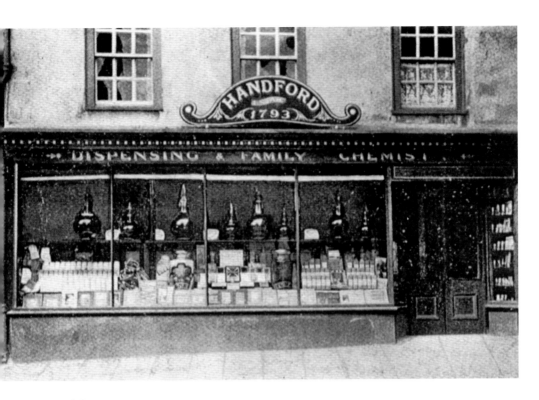

No. 1, High Street

This shop is now Lloyd's pharmacy and seems to have been a chemist's shop for at least 100 years, run by Peter Turton, Pringles, and by 1908, Sidney Buckle. Handford chemist is here in the photograph and says they began as a Dispensing and Family Chemist in 1793, though not always on this site.

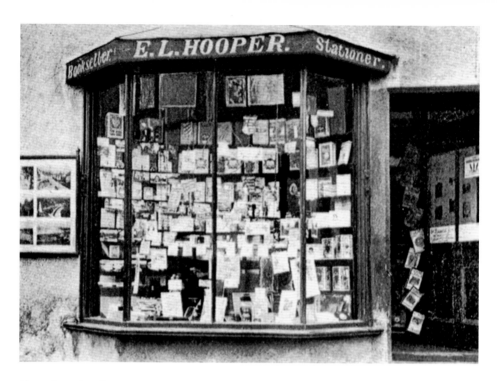

No. 9 Corn Market Street

This old shop has had an interesting life as it was turned into a barracks in the Second World War. It has also been Hooper's stationery and bookshop, then Mrs Babbington's toyshop, and a gift shop in the 1990s. The interesting bow window has survived intact, though the doorway seems to have been moved along to the right of the photograph.

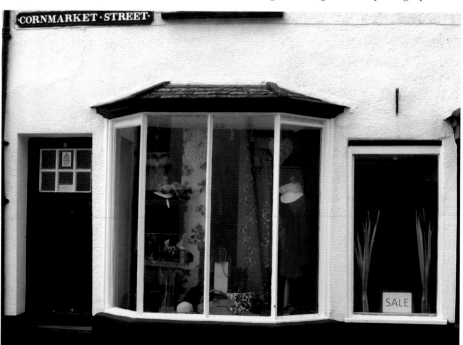

Eastmond Ironmonger

Eastmond Ironmonger was at No. 10 Fore Street in the 1880s, where A&J Opticians are now. They were also painters, plumbers, gas fitters and glaziers, as well as advertising their services as zinc and tin plate workers. Their account records fitting a water pipe and supplying a lamp chimney and paint. The window display has hip baths, a saucer bath, push and pull lawnmower, oil lamps and a brass hearth fender, and hundreds of household goods. After Eastmonds had left, the shop was occupied by various traders, including P&L Trading, selling new and used household and gardening items, and R&G Autos, selling car parts.

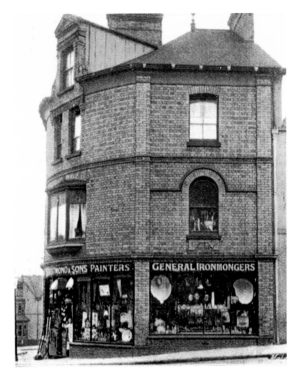

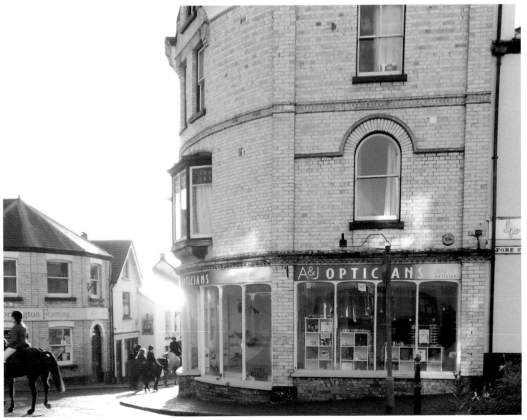

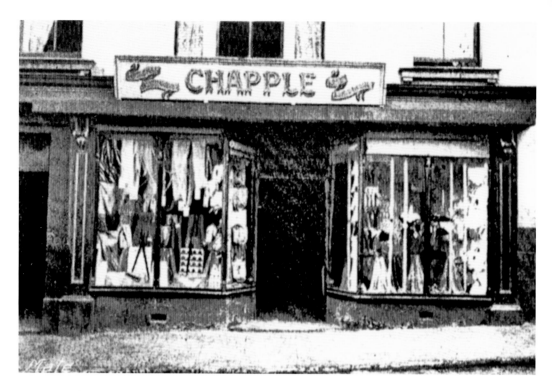

No. 20 South Street

The old photograph shows this shop as Chapple the draper's, advertising itself as a 'Fancy Draper and Milliner'. This shop later became Castle Hill Studio and China Shop, then Plucknetts Electricals, then Swallows' Tea Shoppe and now is Whiskers Pet Centre, which moved round the corner from High Street to open up here.

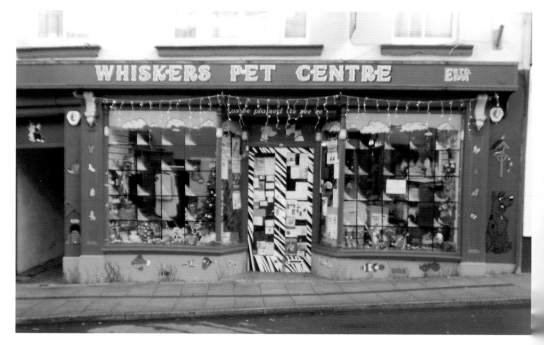

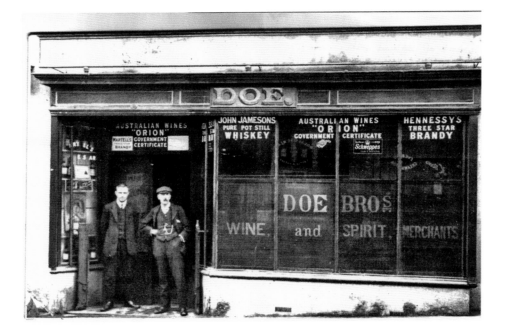

Mr Doe's Shop, No. 18 South Street

Here is Mr Doe's shop, a linen draper's, undertaker's and wine merchant's. The shop window notices read, 'Doe Bros', 'wine and spirit merchants', 'Australian wines', 'Orion, Government certificate'. Also advertised are John Jameson's pure pot still whiskey and Hennessy's three star brandy. By this time, it was already mostly an off licence and the linen draper part had been dropped in favour of alcohol sales. Soon after it became the West of England Inn. Later, it was Captain Jack's Restaurant and is now an Indian Restaurant. The whole shopfront was drastically altered in the year 2000.

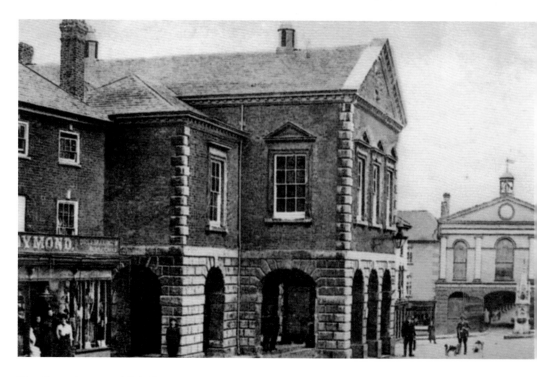

The Green Lantern, High Street

This elegant Georgian house was The Bell Inn, in close proximity to the church, but by 1880 it was James Bray's dressmaking and draper's shop until 1908. Then it became Seth Diamond's draper's shop, later to be Bowdens' outfitters and then The Green Lantern, the much loved bakery and café. Anthony Byrde was renting a shop here when the Town Lands carried out their survey around 1646.

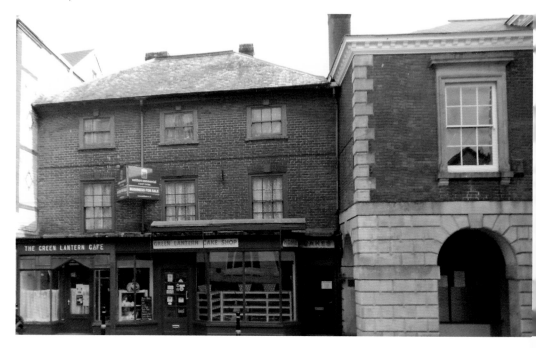

Traveller for World Stores

This is Mr Piper, who was the traveller for World Stores, the big grocery store in South Street, now Co-op. Each week the store sent this man out to surrounding villages to collect grocery orders from customers' houses, and would then deliver the food even to remote houses and farms. World Stores was a nationwide chain of grocers, the forerunner of today's supermarkets, with several others like International and Home & Colonial. Sugar from big sacks was weighed out with scales into blue paper bags, coffee was roasted, biscuits were stored in glass-topped biscuit tins, lethal bacon slicers cut up bacon flitches and the grocer in his long white apron presided over all. Even though there were only four houses and a blacksmith at Huntshaw, here he is outside the tiny village school there.

Heywood & Hodge, No. 16 High Street

There have been many architectural alterations here and the door has now been moved around the side into High Street. The signs advertise cartridges and sporting ammunition, Welsbach incandescent gas light, paper hangings, brushes, linoleum, mats and matting. The shop windows display a microcosm of 1920s domestic life: tin trunks, a saucer bath, carpet sweepers, oil lamps, fish kettles and push and pull lawnmowers, and an old pushchair is outside the door. Heywood & Hodge also supplied local quarries with explosives, which they stored in the basement. There was a private house on this site in the 1640s, owned by Roger Thorne. For some time, this was the well-known bookshop Mole & Haggis, and now it's Jack & Molly, who still sell books and games and children's toys.

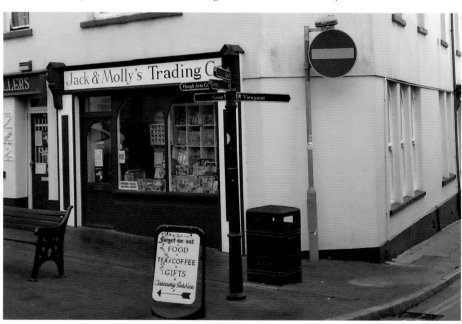

Old House, No. 9 High Street
This shop was remembered with great affection as Mrs Tickle's Sweet Shop. It then became G. Nock tobacconist and confectioner, then Torrington Sports. In the 1990s, Whiskers pet shop was here before moving to South Street. It then became Sarah Lou and then Obsessions, both hairdressers. Once an old house with its lath and plaster construction, it is another typical example of a burgage plot dwelling. Burgage tenements were an excellent way of sharing out the valuable street frontage in medieval times. Each dwelling had a measurement of 1 perch allocated at the front (5.5 yards) but extended backwards to make a long narrow garden plot behind the shop/house. By 1362, Torrington had forty-three burgage plots, which were allotted to tenants, called burgesses, who were tenants of the lord of the manor, to whom rent had to be paid. In Torrington, as in many well preserved towns, these burgage tenements have remained remarkably stable over the centuries and many good examples can be seen here today.

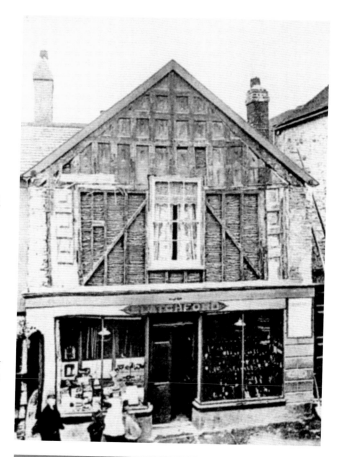

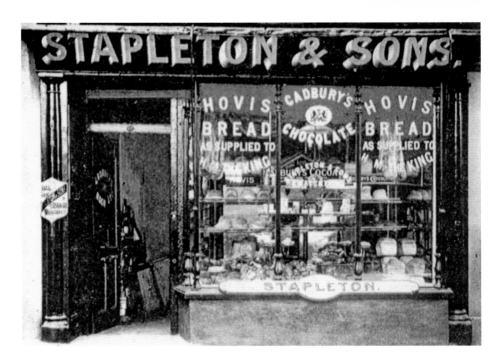

Stapleton & Sons Baker

Mr Stapleton the baker was at No. 3 Fore Street, though he has also had shops in Mill Street and High Street in 1893. He advertises Hovis bread supplied to HM the King and Cadbury's Chocolate and says that public teas and parties are his speciality. The shop is now Toy Zone, but has been completely remodelled, with the door in a different place. After Stapleton it was Luxton the baker, then SWEB, then the Hotpoint centre for washing machines, then Serendipity crafts and gifts and then Ron Martin's Toy Box, before becoming Toyzone.

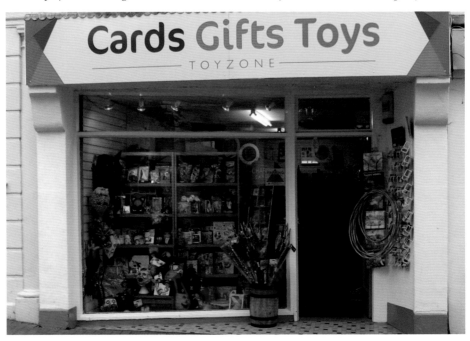

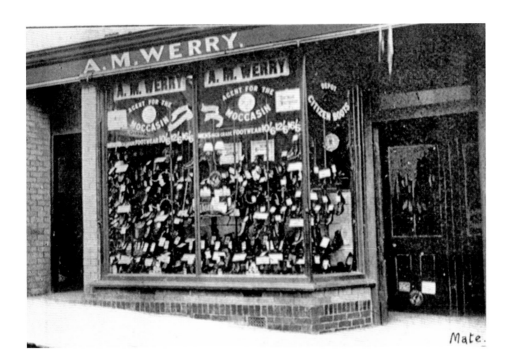

Mate.

Werry Boots and Shoes

Mr Werry was at No. 22 Corn Market Street and his shop window is stuffed full with boots and shoes. He has signs up advertising men's footwear at 10/6, 12/6 and 16/6, and that he's an 'Agent for the Moccasin' and the depot for Citizen Boots. The shop had also been Stapleton's fruit and vegetable shop before the war and later was Mrs Long's wool shop. Now it's the Volunteer Bureau and the front is much altered, but the shop still has a single door on the left of the picture and double doors on the right. Next door, at No. 24, was the Setting Sun pub and there was a Rising Sun opposite.

Streets of Torrington

South Street, Looking East

South Street, running in line with the top of Mill Street and straight into the Market Square, is a very early medieval route way; it was at the heart of the commercial medieval town and was its principal artery. The south side of the street was early burgage plots and the medieval frontages have been retained, with some well-preserved old door cases. This old photograph was sllightly problematic to identify as the left-hand shop is now taller. The square window on the left was once the front room of Mr Nancekivell's cottage with his ironmongery shop to the right, but is now the square window of a pizza shop. The ironmongery shop, now a butcher's shop, is still a double shop with the door in the middle.

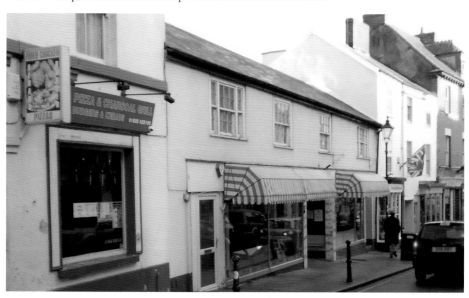

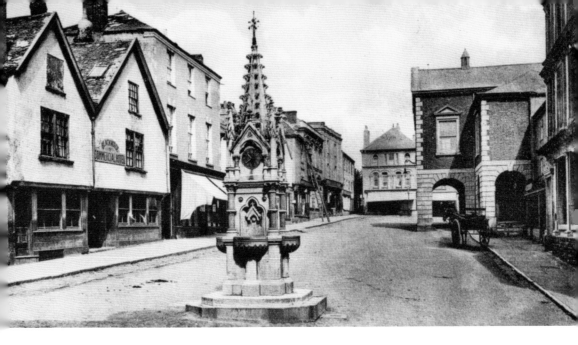

High Street and Town Hall

The old Black Horse Inn, No. 15 High Street, is the first building on the left and an inn has been here since the sixteenth century. During the Civil War, it was the headquarters of the Royalist commander (Capt. Hopton), though it was damaged by the church explosion in 1664. There were once two more inns in this short street: The Bell Inn, now the Green Lantern, and the King's Arms. The town hall, whose pedimented centre stands out into the High Street on the right of the old picture, was rebuilt in 1861 on the site of a much earlier one. Then it was called the Guild Hall and was built in the sixteenth century. The site had a group of assorted old buildings representing the main industries of the busy town: the Leather Hall, the Cordwainers' Chamber, the Yarn Hall and the Shambles, as well as the town hall, which was damaged by fire in 1724 when many old records of the town were lost. The present town hall was built in an elegant classical style and is Grade II listed. The council chamber on the first floor has panelling that came from the old Plough Inn in Fore Street when it was demolished.

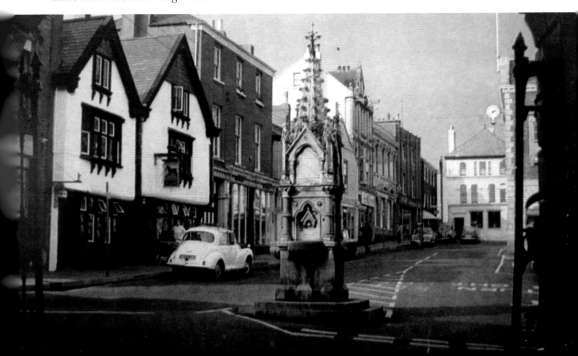

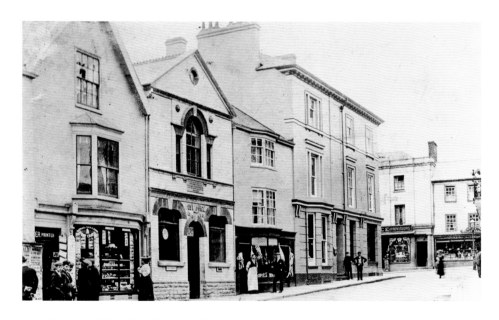

Fore Street and Market Place, Looking West, 1910

In medieval times, the market square area within South Street, High Street, Fore Street and Cornmarket Street was probably a large open market place, with only temporary stalls on market days. In post-medieval times, it was filled in with a guildhall, leather, corn and yarn markets, and a meat market called The Shambles. Later still, these were all cleared away, and the Victorian town hall was built here. However, this area was always the main trading place. Interestingly, historians think that this market area once opened out to the medieval manor house (on the site of the Old Vicarage in New Street) and the church and churchyard area. This seems probable as there are still narrow burgage plots all around the market place, the Black Horse being a superb example. However, there are no narrow plot buildings on north side of Fore Street (e.g., The Globe and The Plough), as though later infilling has gone on here.

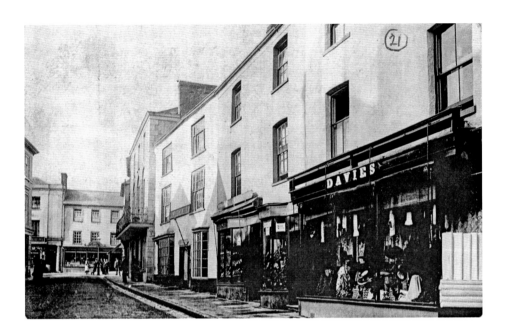

Fore Street, Looking West

The first shop on the right of the old picture was Davies (No. 13, Fore Street), which was a draper's shop at that time, though it was later Dyers the jeweller's. No. 11 Fore Street, the next shop along, was Collins in the old photograph, advertising itself as a watchmaker's and jeweller's. There were several clockmakers in Torrington in the past who both made and repaired clocks and watches, though mostly they made long case or grandfather clocks. By 1797, John Oatway and Mr Dennis were making good quality clocks in Torrington. No. 11 Fore Street is now missing as an address as, together with the Plough Inn next along (No. 9 Fore Street), it has long been demolished. The building of the Plough Arts Centre has replaced them. Next along after the old Plough Inn is the Globe Hotel, with its wrought-iron balcony.

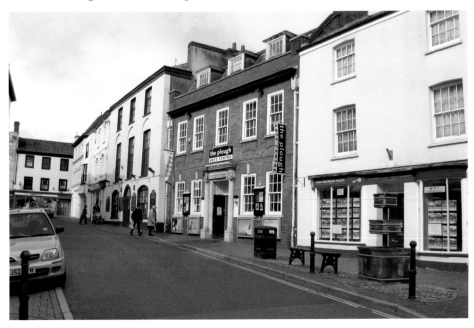

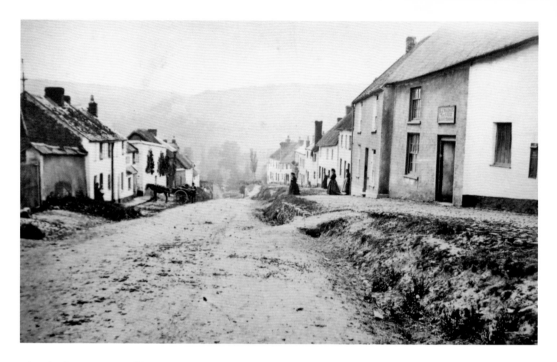

Kingdon's Tannery, Mill Street, *c.* 1880

This very old photograph of the lower end of Mill Street shows the cottage that is now 98A, which was once Kingdon's Tannery. The board over the door says 'Kingdon Tanner and Currier' and the ramp up to the house level from the road is still in place today. After the leather had been through the tanning process, Mr Kingdon, who was also a currier, would finish and dye it to make it supple and shiny ready to sell it on to saddlers, shoemakers and glovers in the town. Further down on the right, two women with long, sweeping skirts have just come out of a cottage followed by a maid, and on the left, a horse and cart waits patiently.

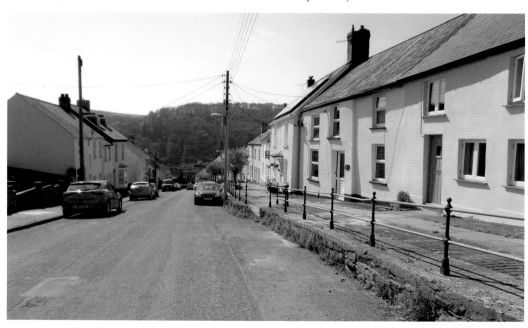

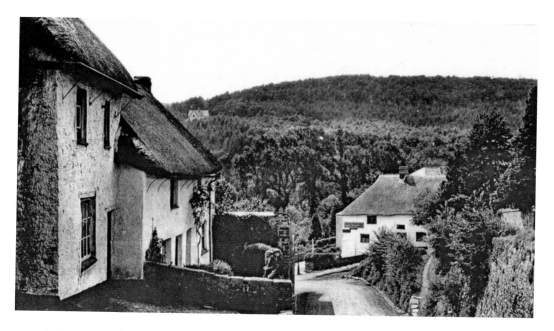

Mill Street and Torridge Inn

Mill Street is a very old road that once led down to the old Manor Mills at the bottom of the street, which comprised lime kilns, a tucking mill, and a grist mill. It was called Mylstret even in 1405 in a deed concerning 'two tenements in Chepyntoryton'. It also led down to Taddiport, or Town Bridge, and was the main access to the town from Plymouth and Hatherleigh. There were five inns here in the nineteenth century: The Greyhound, The Nelson, The Plymouth, the Torridge Inn (which is the only one still in existence) and The Canal Inn, which burned down in 1859. The south-east side of Mill Street was discovered to be the site of a mid-seventeenth-century pottery when housing development was taking place just north of Caynton House. A kiln was found, along with remnants of cloam ovens, clay pipes, ridge and floor tiles, and decorated slipwares.

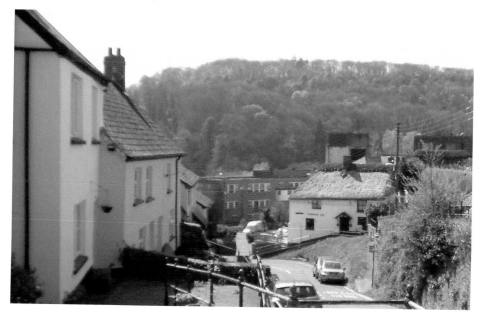

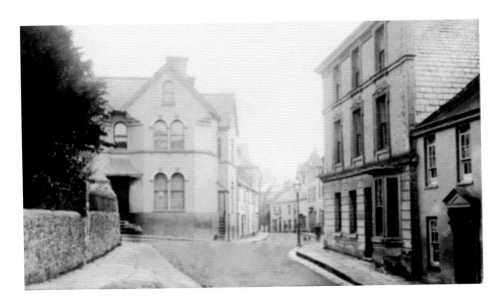

Windy Cross

This is the top of Mill Street at its junction with South Street and Halsdon Terrace. In the old picture, Halsdon House is on the left and Windy Cross House on the right. Halsdon House, with its long, narrow garden, was built as a town house by the Furse family and named after their house at Dolton. When the family sold the house, Halsdon Terrace was built on its long garden. At times, Halsdon House was used as a boarding house and a library. Halsdon House was demolished in the 1960s to ease the corner for traffic, as in the modern photograph. Windy Cross House on the right was built in the early nineteenth century, and an old dumbwaiter rises up from the basement through the kitchen and up to the first floor. There is an old larder in the basement with slate shelves and meathooks. White's Lane was originally in two halves, with the south end broader and forming a continuous lane with Church Lane. The northern part was only a narrow alley going up to New Street, again suggesting that South Street was once the more important access to the town. When the two halves became a seamless street, it was Church Lane, a lesser alley with small industries – a smithy and a tannery.

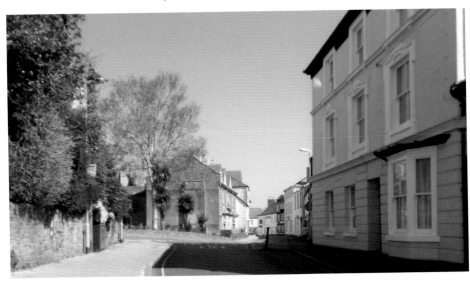

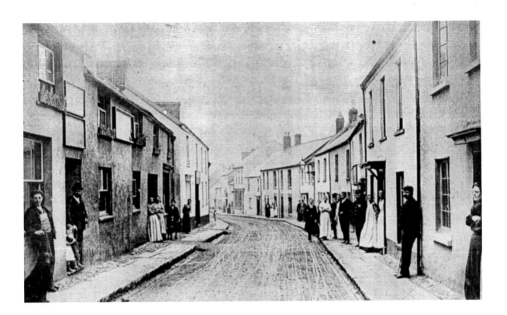

Well Street, Looking East

This very early street was once the main route into the centre of town from the east. It was divided into two separate halves by the extension of New Road. The part of the street nearer to the town centre has medieval burgage plots on both sides, but the further end has post-medieval plots and was built up later. The early plots on the south side of the street have the reverse S-shape, which are usually a sign of the conversion of medieval field strips to be urban tenements. A deed of 1585 refers to it as Wyllstreat (Old English 'weille', meaning a well). The street was the site of a Royalist barricade during the Battle of Torrington in the Civil War and fighting raged through the streets. Hopton's horse was shot from under him. The 1843 town map shows the Bluecoat School at the eastern end, and the 1880 map shows a leather manufactory in this street. There were five inns here once: the Hunters' Inn (which became The Cavalier), The Barley Mow, The Malt Scoop, The New Inn and The Old Inn. Many inns had backyards, which were used by farmers who were en route to the market, and their horses could be left for the day here.

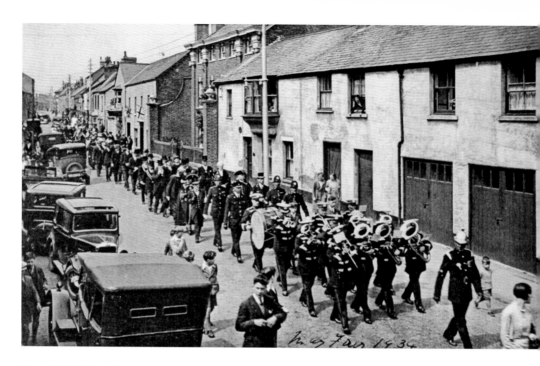

May Fair in New Street, 1934

Fairs have been held in Torrington since around 1220, with a cattle market in New Street. Funfairs were held in the streets and on Barley Grove, with stalls, boxing booths, maypole dancing, shooting galleries, peep shows, a greasy pole, wrestling matches, floral dances, races and bull baiting at the Bull Ring in Church Walk, followed by the bull being released into the streets to the excitement of the crowd, as they still do in Spain. The fair often went on for several days and into the nights as well, with coloured lights, hooters, church bells ringing and much toasting in cider. Here, the procession, led by the town band, is making its way along New Street and has just passed Palmer House.

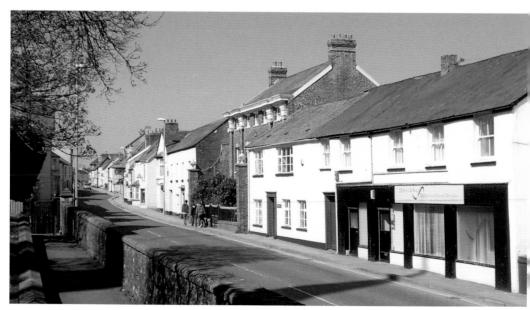

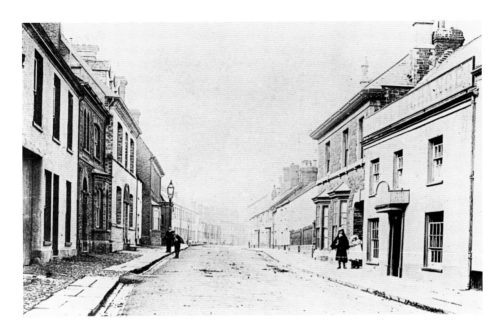

New Street, Looking West, *c.* 1895

This street is named New Street, though all things are relative, as it was called 'Nywystret' in 1382 (Old English 'nywe', meaning new). In the old photograph, the street is of compressed mud with cobbled inner pavements. The Royal Exchange is the first building on the right, though there were several other pubs and inns in the street (now gone): Ring of Bells, Barnstaple and Bideford, The Tradesmen's Arms, The West Country Inn and the White Hart. The next house on the right after the Royal Exchange is No. 88, the old glove factory, and there was even a pub called The Glovers' Arms (now also gone). Originally, the street was lined with medieval strip fields, which were replaced by workers' housing for the many glovers of the town. The street was upgraded in the 1820s as part of the Turnpike Road to Bideford, and after 1872 it became the route to the railway station.

Church Walk

The man in plus fours is almost at the kissing gate at the north end of Church Walk. The scene remains remarkably unchanged, although the old railings were melted down for use in the Second World War and never replaced. Until 1855, all interments were made in the churchyard until more land was needed. Barley Grove was suggested in 1833, but eventually a parcel of commons land at the end of New Street was converted as an alternative graveyard. Churchyards were usually walled, with entrance gates to keep out wandering grazing animals and to prevent them from eating poisonous yew berries (yew trees were often grown in the safety of churchyards because the wood was best for the manufacture of archery bows). However, in 1754, the churchwardens were in trouble for 'suffering rubbige in the Churchyard and not repairen the Church Gates', and James Grant was reprimanded 'for not keeping the Church Yard Gates fast and for suffering pigs and horses to graze therein'. Kissing gates were especially favoured for keeping out wandering animals as they are easier to negotiate than stiles when dressed in one's Sunday best.